ITALY
'50s

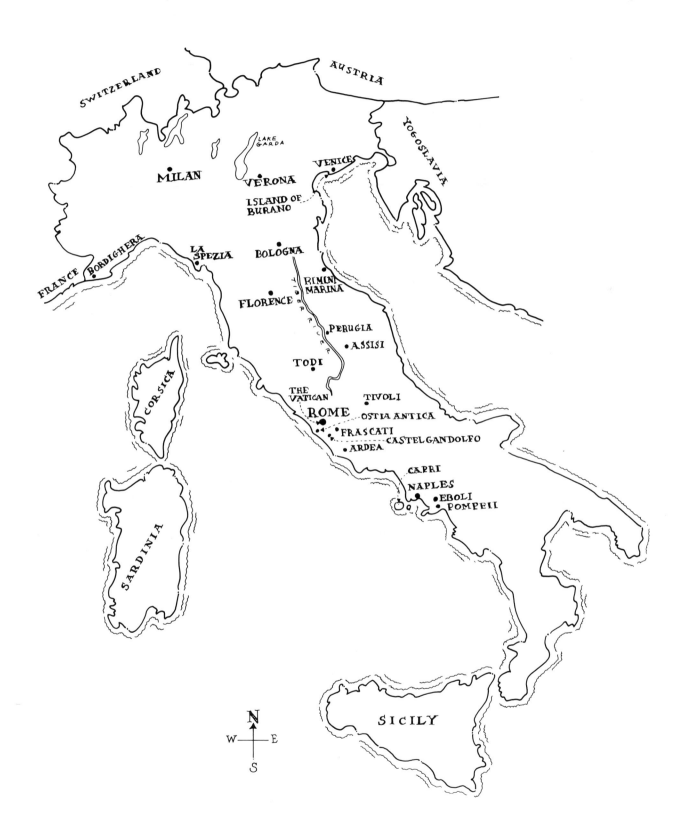

PHOTOGRAPHS BY SANFORD ROTH

ITALY '50s

FOREWORD BY KENNETH BAKER
TEXT BY BEULAH ROTH

Mercury House, Incorporated
San Francisco

Copyright © 1990 by Beulah Roth
Foreword © 1990 by Kenneth Baker

Published in the United States by
Mercury House
San Francisco, California

Distributed to the trade by
Consortium Book Sales & Distribution, Inc.
St. Paul, Minnesota

All rights reserved, including, without limitation, the right of the pub-
lisher to sell directly to end users of this and other Mercury House books.
No part of this book may be reproduced in any form or by any electronic
or mechanical means, including information storage and retrieval systems,
without permission in writing from the publisher, except by a reviewer who
may quote brief passages in a review.

Mercury House and colophon are registered trademarks
of Mercury House, Incorporated

Manufactured in the United States of America

Library of Congress Cataloging-in-Publication Data

Roth, Sanford, 1906–1962.
 Italy '50s : photographs / by Sanford Roth ; foreword by Kenneth
Baker ; text by Beulah Roth.
 p. cm.
 ISBN 0–916515–72–9 : $24.95
 1. Photography, Artistic. 2. Roth, Sanford, 1906–1962. I. Baker,
Kenneth, 1946– . II. Roth, Beulah Spigelgass. III. Title.
TR654.R6794 1990
779'.092—dc20 89-27617
 CIP

Dedicated to the memory of

my husband,

Sanford Roth,

and of our dear friends

Afro

and

Nino Franchina,

and to

the efforts of

the Save Venice committees

Also by Sanford Roth

Portraits of the Fifties

Paris in the Fifties

CONTENTS

FOREWORD

Kenneth Baker

Photographs are not supposed to tell us about what is behind the camera, yet often they do. Sanford Roth's pictures mirror a personality that seems to have put both acquaintances and strangers (and even animals) at ease. (Bear in mind that the artist's wife, Beulah, was usually behind the camera too.) Rarely in his photographs taken in Italy in the 1950s do you sense that he intervened in or occasioned what he recorded. Too many other forceful personalities are at the center of his images: film industry people, street vendors and performers, Vatican pilgrims, and above all artists—painters and sculptors.

Most of his subjects did not mug for Roth's camera (some of the performers, including a melon vendor, are exceptions), but they did come out of themselves. Even as hermetic a figure as Giorgio Morandi presents himself in Roth's portrait as concerned to be understood, despite his obvious self-possession. Roth was also allowed to record Morandi's repertoire of still life objects, which he did with wonderful reserve. How easily the fragile clusters of bottles, vases, and tins might have been made to look like targets in a shooting gallery by someone who wielded the camera like a weapon. Instead Roth showed that the camera could see what even some critics and fellow artists could not: how these objects might sustain a painter for decades. He shot them at a low angle to catch the rhythm of their family resemblances and their economy as silhouettes and as receptors of daylight.

It is hard to guess whether the optimism that pervades many of Roth's pictures of Italy in the 1950s is a period quality, a mood imposed by his own temperament, or a nostalgic illusion of ours. Still harder to know is the origin of the cinematic quality that Roth's pictures of people in Italy have (in contrast those he took in France, for example). The photos of movie people—Monica Vitti, Romy Schneider, Alain Delon, Ava Gardner, Michelangelo Antonioni—are among the least cinematic-looking (the portrait of Rossana Podestà is an exception). It is the shots of a back street in Naples, of children in a courtyard, of young men watching a movie being made in Todi, and the

other glimpses of ordinary life that suggest outtakes from Rossellini, Antonioni, or even Fellini (see the costumed men in the Frascati festival). Is it simply chance affinities between Roth's images and those of the filmmakers that explain this quality? Did the Italians know intuitively (from watching movies) how to comport themselves as figments of someone else's artistic vision? Or did Roth, so familiar with the moviemaker's world, yield unconsciously to some cinematic tropism of his own temperament? It is interesting to note how journalistic Roth's portraits of painters look in contrast to the pictures of street life. It is almost as if the painters and actors, conscious and in control of their relationships to art, did not participate in the demotic vogue for self-cinematizing.

Most of the painters and sculptors Roth photographed had made their reputations before World War II—in some cases, decades before. But during Italy's recovery from the war and Fascist rule, they worked under peculiar pressures that appear to register occasionally in the portraits (those of Pericle Fazzini and Alberto Viani, for example). Beulah Roth attests that political tensions sometimes strained sociability in the circle of painters in Rome that she and her husband enjoyed, which included Renato Guttuso, Pietro Consagra, Afro Basaldella, and Giulio Turcato. The artists Roth photographed lived through World War II as adults and were sensitized to the complex question whether social and political ideals ought to dictate artistic style. Bitter debate raged among Italian artists during the decade after the war about how contemporary art could be of its own time.

The political instability of postwar Italy gave the issue far greater moral weight than theoretical questions in the arts ordinarily have. Mussolini's Fascist regime had taken control of cultural institutions in the late 1920s but, unlike its German counterpart, never really set policy for the visual arts. Mussolini himself hesitated (perhaps shrewdly) to put his imprimatur on most of the stultifying measures proposed by ambitious bureaucrats in his cultural ministries. His seeming indecisiveness on matters of cultural policy created a climate in which even some dissenting intellectuals and artists could follow their own artistic inclinations, at least until 1938, when Fascist propaganda became explicitly anti-Semitic and anti-modernist.

Filippo Marinetti, poet and founder of Futurism, Italy's most important contribution to modern art, became an official of the Reale Accademia d'Italia, which was created to lend intellectual legitimacy to the Fascist regime. He never tired of asserting that Futurism should become the official style of Fascist Italy, even during a period of friction with the regime. But by the time Mussolini assumed dictatorial powers in 1925, Futurism had

evolved into something very different from the works that first wore the label—those by Luigi Russolo, Umberto Boccioni, Giacomo Balla, and Gino Severini. The early Futurist art was derived from innovations in Parisian painting: Analytic Cubism and Divisionism, the dissolution of solid form into scintillas of vibrant color. Early Futurist painting celebrated the mechanical energy, movement, vividness, and violence that Marinetti saw as the essence of the modern world—forces that would sweep away a moribund past. Balla and Boccioni adapted the overlapping planes and visual stammers of Cubism to render the motion of vehicles and bodies and the swirling of energy around them.

"There is no more beauty except in strife," Marinetti wrote in the Manifesto of Futurist Poetry, "no masterpiece without aggressiveness. Poetry must be a violent onslaught upon the unknown forces, to command them to bow before man.... Why should we look behind us when we have to break [through] the mysterious portals of the Impossible. Time and space died yesterday. Already we live in the absolute, since we have already created speed, eternal and ever-present."

By the time Mussolini took political control, however, what is known as Second Futurism had eclipsed the style Marinetti originally championed. Stemming from the early Futurist fascination with the machine, Second Futurism developed into an obsession with aerial views of landscape, symbolizing a transcendent consciousness of life. It licensed stylized and bizarre perspectives that were thoroughly modernist. Futurist political activity was stifled by the Fascist regime, and the artists' polemical energies were diverted into their art and into debates with artistic competitors for official recognition, principally the neoclassical Novecento group, which included Mario Sironi, Arturo Tosi, and Carlo Carrà, one of the original Futurists. Debate raged during the 1930s about which contemporary art was authentically Italian, the one that merged classical and modern motifs, like the work of Carrà and Sironi, or the one that subjected international styles to Italian sensibility, like that of Fausto Pirandello and the abstract work of Lucio Fontana. The underlying issue was always the battle between art for its own sake (subject to "internationalist" influence, and thus dangerous from the Fascist perspective) and art serving a social and national purpose.

Complicating the debate and the artistic scene in Italy was the other great seminal development in modern Italian painting, the so-called Metaphysical School, personified before 1920 by Giorgio de Chirico, the young

Giorgio Morandi, and, for a time, Carlo Carrà. The work of De Chirico, his brother Alberto Savinio, Carrà, Filippo de Pisis, and a few others developed into a strange pastiche of art historical references and contemporary social satire. These painters insisted that artistic freedom was best expressed by a playful raiding of art history that would keep any official interpretation of Italy's cultural past from taking hold.

It was against this background that many of the artists seen in Roth's photographs defined themselves. The ambiguous and opportunistic nature of Fascist cultural policy prior to 1938 ironically had the effect of keeping even the most sycophantic artists off balance, allowing a variety of styles to coexist. In the postwar years, up to 1960, debate was renewed by many of the same artists.

In the late 1940s, some, such as the painters Renato Guttuso, Leonardi Leoncillo, and Alberto Viani and the sculptor Pietro Consagra, declared themselves "Formalists and Marxists," arguing that abstract art was the most progressive style possible, precisely because it overthrew people's habits of seeing that had been formed by a corrupt, enslaved society. A few, such as Guttuso, later reversed themselves stylistically, though not politically, having decided that only an art of recognizable social content could promote social change.

Between the poles of the debate arose the abstract decorative work of Giuseppe Capogrossi, Toti Scialoja, and Piero Dorazio, the fractured paintings of Emilio Vedova, and the gritty collages of scavenged materials by Alberto Burri. More than any other artist of the 1950s, Burri foreshadowed the revolutionary art of the 1960s—the bizarre provocations of Lucio Fontana, Piero Manzoni, Michelangelo Pistoletto, Jannis Kounellis, and others still associated with Arte Povera, the movement that would reclaim international attention and credibility for Italian art.

The painters who appear in Roth's photographs were the old guard who struggled to find their stances in respect to anachronistic tradition and war-torn modernity. (The possibility of religious art was believed by many to have been vitiated by the Vatican's tolerance of Fascism.) For all the inner turbulence these artists may have felt, Roth's portraits appear to capture a moment of calm before the onslaught of innovation in the 1960s. It is hard to imagine that, had he lived, Roth would have felt the same sympathy for the next generation of artists that is expressed in his portraits of Marino Marini, Giacomo Manzù, Carla Accardi, and Carlo Levi.

ITALY '50s
Beulah Roth

ROME Rome is not the same to everyone. The poet sees it one way, the painter another. The historian follows the footsteps of Claudius and Caesar, the architect is impassioned by the symmetry of a Doric column, the tourist remembers the photographs in a geography book or the film versions of Rome in its glory. On my first visit to Rome, long before I dreamed of living there, the city seemed a living history. I tried to analyze the color of Rome, the startling combination of grays washed with white where the rain had removed the grime of centuries, the faded burnt umber and ocher buildings that give Rome its character. Then there were the new structures influenced by Hitler's architects—stark, steel-gray stucco without sentiment, built for utility without ornamentation of any kind. They were Mussolini's revolt against the classicism of old Rome, a nod in the direction of Adolf Hitler, a symbol of the new Italy.

In 1948, the year of my first visit, all of Italy was recovering from years of deprivation during World War II. A new breed of young men was growing up determined to recover their losses as soon as possible, primarily from tourists who came to Rome after the war. I confess that my husband and I were the victims of a young sleight of hand genius who changed our dollars into a packet of cut newspapers right before our eyes. He showed us *lire* but gave us the false bundle. Dealing with black market money changers on the street was against the law, so we couldn't report him to the police without facing a huge fine or even possible deportation. I hope this clever thief used his talent in another direction eventually. I sometimes picture him as an industrial tycoon living the *dolce vita* in a palazzo on Capri or an apartment in Trump Tower in New York.

We saw another face of Rome that year at Cinecittà, the film studio in Rome where many great films were to be made. Cinecittà was chosen by the International Relief Organization (IRO) as the site for a displaced persons' camp. We were taken there by a young man we met at a bicycle race at Rome's Velodrome. He was very helpful in

explaining the Italian method of racing to my husband, who had been a bicycle enthusiast in his youth. Our new friend told us that he worked for the IRO as an interpreter and invited us to visit the camp with him. There, separated by a barbed wire fence from the rest of the studio, were former inmates of Buchenwald, Auschwitz, and Dachau living in makeshift shelters, cooking over open fires, and drawing water from an ancient Roman well. They were grateful to be cared for by the IRO despite their Spartan existence. Soon the red tape would be unraveled, and they could return to their former homes, if those dwellings still existed. Or they might migrate to Israel, Australia, or the United States. I will never forget that day at Cinecittà. On the other side of the barbed wire, a motion picture company was doing business as usual, filming some medieval epic. Tyrone Power, costumed as a knight, galloped away on a black horse, with his lance at the ready.

My husband insisted upon calling himself a photojournalist. His documentary stories on Christopher Isherwood and Edith Sitwell appeared in *Harper's Bazaar* and caught the attention of some farsighted publicity man at Metro-Goldwyn-Mayer who hired Sandy to photograph Joan Crawford during the filming of *Torch Song.* Those photographs and the magazine space they received gave other studios the idea of using a photojournalist. With his numerous Nikons and thirty-five millimeter film, Sandy photographed the stars very informally off the set and during rehearsals. Soon directors, actors, and producers were giving him more work than he could handle. He traveled all over the world—from Australia to the Belgian Congo, from Morocco to England, from Japan to France and Italy. Sandy worked on twenty-five of the most important films of the fifties. One of the first to be done abroad was *Helen of Troy.* This is how we stopped being tourists in the Eternal City and became Romans, or a reasonable facsimile. As long as you live in a hotel, you are a visitor. Until you have your own apartment and live, eat, dress, and behave as Romans do, you are not one of the *populus Romanus.*

Robert Wise, the American director of *Helen of Troy,* worked with a cast of thousands, including such well-known stars as Sir Cedric Hardwicke, Rossana Podestà (playing Helen), and Jacques Sernas (playing Paris). One American actor, Dean Severence, who had a featured part, told me that he and the other actors playing Trojan or Greek warriors had to have their bodies shaved daily and then were painted with gold pigment. Dean and a few others occasionally fainted from this assault to their pores.

The costumes and set decorations were beautifully authentic, but the most spectacular element in the pro-

duction was the Trojan horse. It was reputed to have been constructed according to Homer's specifications. By coincidence, our friend Aldous Huxley was in Rome, and he was an expert on both Homer and the fact and fiction surrounding the legend of Helen of Troy. The day the horse was brought onto the set, Huxley came to Cinecittà to see the replica for himself. Its authenticity amazed him, and he congratulated the studio carpenters on the dimensions, the choice of lumber, and the finished interior of the horse, which he examined personally by means of a ladder. The presence of Aldous Huxley did not impress the Italian crew, but the British actors watched him with awe and actually queued up to be introduced to one of their nation's literary lights.

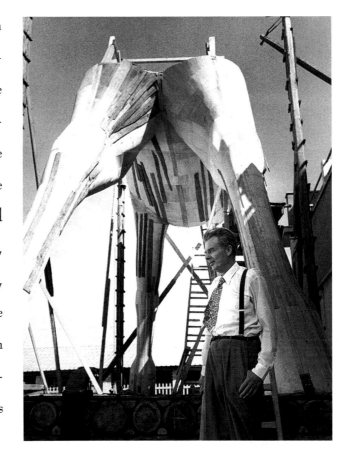

While the Italian crew wasn't interested in Huxley, it very much admired a young French actress who played Helen's handmaiden. Something about her intrigued me, too. Her face reminded me of a beautiful young tiger's, and she had a feline quality. I was not surprised when, years later, she became the sex kitten of France. Brigitte Bardot is the second greatest animal lover in the world (I am the first). Now that she has retired to the south of France, she devotes her life to the protection of animals.

Somehow we found out about a Lady Bountiful at the British Embassy who had done magic finding furnished apartments for the cast of *Helen of Troy*. We bribed her with a dinner at Tre Scalini, and the next day she called to tell us that there were two apartments available suitable for a long stay in Rome. After an elegant lunch at Ranieri's (another bribe), she led us to the first flat on her list. It certainly was desirable, with three bedrooms, a salon, a dining room, and—wonder of wonders—two full baths and a kitchen with a refrigerator. The *portiere* opened the door, and I was awed by the magnificence of the furnishings: Directoire pieces, painted Venetian chests, an Aubusson carpet, and one or two Roman marbles that should have been in the National Museum. The rent was

reasonable, and just as we were about to say "We'll take it," I asked the *portiere* to open the salon shutters so we could see the view.

"No, Signora, it is not possible, not ever. You must never open the shutters and look out the window."

I was stunned by this unusual request, but the explanation followed immediately:

"The windows we are discussing look down directly into the gardens of a monastery next door. The monks of this order forbid the eyes of a woman to view them."

I am very curious by nature, and I knew that eventually I would break the rule and peek at the activities below—innocent or otherwise. Our better judgment prevailed, and we left these rooms without a view to other occupants, perhaps gentlemen who might bear witness to the antics of the monks. Personally, I think they grew marijuana in their secret garden, an occupation frowned upon by the Italian government and punishable by exile.

The next place we saw eventually became our loving home. It was at 21 Via di Villa Ruffo on the second floor of twin buildings owned by a countess. She was an actual Italian countess, not an American who had married a title—Rome was filled with those. Fortunately for us, this countess loved cats and welcomed ours with enthusiasm, even suggesting that the furniture (upholstered in green velvet) needed recovering and that a cat's claws would have no adverse effect on the already shabby fabric. Via di Villa Ruffo was a small street that ran from nearby Piazza del Popolo up a small hill facing a perimeter of the Borghese Gardens. The street was named for a large villa occupied by a Vatican prince. We watched from our windows as long black limousines flying the flags of the Vatican and the Knights of Malta arrived throughout the day. I imagine they brought visiting church dignitaries for breakfast, luncheon, tea, and dinner. The villa was hidden behind a mass of trees and shrubs, so we could not see who the visitors were, but it wouldn't have surprised me if the Pope himself had been one of them.

He must have blessed our building on his way to the villa, because we began to have some extraordinary luck. Soon after we moved into our new abode, I called an employment agency for a housekeeper. My specifications were simple—she had to speak French (because my Italian was rudimentary and Sandy's nonexistent), be fond of cats, and have a few good references. That is how the blessed Madellena came into our lives. Her references came from various *dottori, commendatori, princepesse,* and a hotel on Lake Garda, where she had worked twenty years before. I didn't even read them, because Madellena's face and demeanor reflected instant love and devotion. French

was a second language to her, and she spoke with the terrible accent of the region around Marseilles—a guttural French that made her, and eventually me, sound like Marcel Pagnol characters. Nevertheless, Madellena was a jewel, the Kohinoor diamond in the rough. She not only taught me about Rome but also turned the mattresses every day, washed the sheets in a tub of cold water on the roof, and catered to Louis, our cat, as if he were a royal prince. Madellena lived in Castel Gandolfo, the location of the pope's summer residence, where her father was gatekeeper. She had known every pope personally and brought us flowers and magnificent Castel Gandolfo peaches from the gardens, which she had blessed each day by His Holiness. I learned a lot about the Vatican from Madellena. It was a separate country, not part of Italy at all; therefore, merchandise purchased within it was not subject to any customs duty or tax. There was a sort of post exchange in the Vatican where one could buy anything—French perfumes, cashmere sweaters, imported groceries and cigarettes—at very low cost. Being a resident of Castel Gandolfo, Madellena had shopping privileges, much to our joy, considering my husband's fondness for Chesterfield cigarettes.

My first lessons in living Italian style came from Madellena. She started by introducing "her *signora*" to all the market people on the Via Flaminia. This was an open air emporium that closed at noon. There were vegetable and fruit, egg, fish, poultry, and meat stands, and of course a *tripperia,* which sold the innards of beef, a bloody mess of lungs, heart, spleen, kidneys, and liver. The butcher of these ungodly treats was a short,

sloppy man who wore a filthy apron and wrapped each purchase in newspaper. I was a patron of his because my cat's daily diet consisted of beef or lamb kidneys or beef liver. Sometimes I would buy a whole lung, which the butcher would cut into a thousand bloody marshmallows so that I could feed some of the homeless cats in my neighborhood.

One day I discovered that the toilets in our bathrooms were overflowing, the water blocked by some debris in the drains. I asked Madellena what could have caused this plumbing crisis. At first she was hesitant to explain,

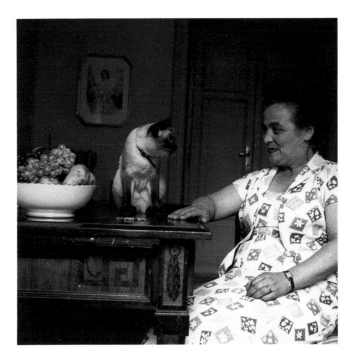

but then, looking like a child who has eaten the forbidden chocolates, she admitted that she had thrown newspapers away to protect us from an informer. I was amazed! What informer? What newspapers? The Rome *Daily American?* The London *Times?* The Paris *Herald Tribune?*

"No, Madame, not those. It was the Communist paper the *trippaio* (tripe butcher) used to wrap Louis's food."

"But," I asked, "why didn't you put it in the scavenger's bag that's collected every day?"

"You see, Madame, if he saw *Unita* in our rubbish he would report you to the police as a Communist. I did it to protect you."

I had to forgive her for protecting me from a political inquisition, and possibly worse. What would he have thought of all the blood saturating *Unita*'s front page? Certainly that could have been a clue to a murder, a bonanza for any informer.

To make our lives more bearable and to keep our drains clear, I changed my *tripperia* and bought the cat's food a few blocks away. I was assured that our scavenger would be proud of our rubbish now that he saw *Corriere d'Italia,* a conservative newspaper, in our trash bag.

During my first week of housekeeping in Rome, I had to find sources for the necessities of life. Two of these were salt and milk. Salt (and pepper, too) came from an unlikely place—the pharmacy. As I entered the druggist's shop, with its apothecary jars and large glass urns filled with colored water, I saw the strangest scale, a relic of the Victorian era. It consisted of a large wooden armchair suspended by a chain that connected to a dial that registered one's weight. Curious to see how this antediluvian instrument worked, I sat on the chair and looked up at the news it revealed about my weight. The needle went to nine and a little farther. What did that mean? I understood kilos and pounds, but this was some other system of avoirdupois. Finally the druggist came to my assistance, bearing with him a half pound of salt as though it were diamond dust.

"This is an English scale, so it registers in stones," he said.

I had to think seriously about stones. How much was one stone in pounds? My New York education had never touched on the subject. The pharmacist again came to my aid: a stone equals fourteen pounds; therefore, my weight was nine times fourteen, plus another fourth of a stone, bringing the total frighteningly close to 130 good old American pounds. I had gained six pounds in a week from a passionate indulgence in *fettuccine* with butter and

cheese for lunch every day. Continuing this habit would certainly lead to my wearing a loose caftan of indeterminate size for the rest of my life.

A few weeks later one of my friends informed me that the sale of salt was confined to tobacco shops by a government control. The pharmacist, I realized, had no right to sell salt. Was his shop a salt speakeasy, or was he dealing in a nefarious salt black market? Or was it really salt or a chemical imitation? The answer was to flush it down the drain.

I'm reminded that eating pasta in Italy has its own etiquette. One rule is that pasta is eaten only at lunch, never at dinner. Another is that the use of a spoon to guide your pasta onto your fork is considered the very worst of table manners. Americans who do this by habit in restaurants incur the wrath of pasta-eating Italians, who may even point at this disgraceful behavior and utter anti-American epithets.

Having solved the salt quandary and resolved to exercise more discipline at lunch, I moved on to the other necessity of life—milk. I know how embarrassing it is to be known as a milk-drinking adult in a world where milk is usually replaced by other potables after puberty. In Italy, where milk-drinking stops when a child is weaned, I was shocked to discover that the source for *latte* was our café and bar, Rosati's—and every other café and bar in Rome. I soon figured out why. Bars are the greatest milk consumers in Italy because they serve *caffé latte* and *cappuccino*. It takes gallons of milk to carry coffee-drinking Italians through the day. Bartenders were happy to sell you a pint or a quart if you brought your own container. And excellent milk it was, too—pasteurized and full of forbidden but delicious butterfat. I had a variety of milk jugs, and, miracle of miracles, our kitchen contained a refrigerator. It was small—so small, in fact, that our ice cube tray had exactly four compartments in which to freeze water. Everyone thought the idea of a grown woman drinking milk was preposterous. A few bartenders assumed that I was pregnant, or feeding a child or an invalid, or taking beautifying milk baths.

The bars were a wonderful source of another delicacy: whipped cream. When I realized that this was available ready to use, I became a regular customer for *panna.* The whipped cream, plus two layers of sponge cake, which the bakery called *pane di Spagna* (Spanish bread—but no bread looked like that!), plus a pint of strawberries made the best shortcake in the world. I stopped using the druggist's scale, because I knew that the dial would gradually move from nine stone to ten or even eleven.

Through our friend Salvatore Scarpitta, an American painter living in Rome, we soon became part of Rome's artist colony. Our friends were Nino and Gina Franchina, Alberto and Minza Burri, Pietro and Sophie Consagra, Afro (Afro Basaldella), Toti Scialoja, Pericle Fazzini, Giuseppi Capogrossi, Renato and Mimise Guttuso, Giulio Turcato, Antonio Corpora, and Carla Accardi. Our meeting and drinking place was Rosati's on the Piazza del Popolo, the center of *la vie bohème,* situated near Via Margutta, Via Ripetta, and other streets where many of our friends lived and worked. The Franchinas' apartment

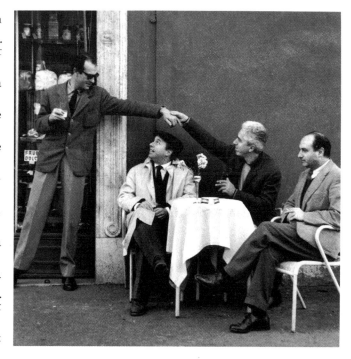

and studio at 51 Via Margutta was used in the film *Roman Holiday.* It didn't take long for the tourist bus companies to add 51 Via Margutta to their tour routes so that visitors to Rome could see where Gregory Peck and Audrey Hepburn fell in love.

We would gather at Rosati's at noon and at six. The Franchinas and the Consagras were there almost every day, since they lived closest. At noon we would have a pre-lunch campari and then go home to lunch, siesta, and work. In the evening, it was different. There would often be six, eight, ten, or eleven of us. We drank vermouth or *Mistra,* a liquor similar to Pernod—diluted with water, it had the same anise taste and was quite potent. It was known as the drink of the working class and the lower depths of society. When one of our friends ordered it at the Excelsior Hotel, he was told in no uncertain terms that it was not served at an establishment with a reputation like the Excelsior's.

Going to a restaurant for dinner with ten people made us uneasy at first. Who would pick up the check? Were we considered affluent because we were American? Roman restaurants, we discovered, were used to this mass dining custom, and there was never a problem with the bill. After a meal, the waiter would come to each person and ask what he or she had eaten. Sometimes it was hard to remember, but someone sitting next to you would remind you that you *did* have a salad with *finocchio* or an *antipasto.* The price of your food was then computed in pencil on a

paper pad and passed to you. Even husbands and wives got separate checks. At times we would take our friends' checks; at other times, they would pay for ours.

Those friendships made in Rome are still vibrant in my memory. Nino Franchina died a few years ago, and Afro's death was not only a great shock to me but also a loss to the art world. This gentle, elegant man is with me every time I look at the two small paintings he gave us. I also have two of his palettes, simply boards covered with newspaper on which he mixed his paints. He mixed dry powders with Vinavil, a polyvinyl emulsion that was used as a glue, a shellac, and a medium for mixing colors. I think it had a million other uses, and I wondered why no

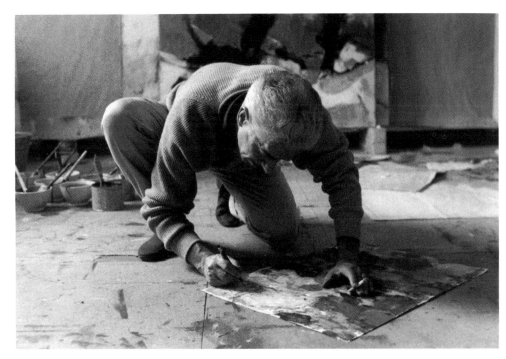

American company had seen the potential of this versatile product. Afro's palettes, with their slashes of reds, yellows, blacks, whites, and blues, were so spectacular that we asked him to give them to us. He did, but was amused by the idea. On one of them he wrote, "To Sandy Roth, who must be crazy to want this!"

Our friends took widely differing positions on political issues. Just before an election, the strain was magnified. They would be polite to one another but found implausible excuses not to join us for dinner or come to a party if so-and-so would be there. The so-and-so in most cases was Renato Guttuso, an ardent Communist who later became a senator. We loved the Guttusos, and, although it was risky at the time for an American to be on intimate terms with anybody on the Left, our friendship with them continued. On the day before elections, each party, from Monarchists to Communists, was proclaiming its views at political rallies. The Communist demonstration was in a square in front of a great cathedral. Sandy and I were in the crowd to photograph it, as we had all the others. On a platform decorated with red flags and bunting, garlanded with red carnations, stood our friend

Renato, delivering an oration, and an oration it was! At one moment his eyes met ours, and he beckoned us to come sit with him on the platform with the heads of the Italian Communist Party. We decided to leave immediately. The eyes of the American Embassy were everywhere, and we didn't relish the idea of a confrontation with Mrs. Clare Boothe Luce, our ambassador in Rome at the time.

Nino Franchina was a sculptor who worked with metal. His wife, Gina, the daughter of Gino Severini, became my best friend. Gina was one of the best dressed women in Rome. I'm not referring to *alta moda* silks, satins, and furs. Gina's style was unique. It was not bohemian, but it was individual. She wore Gucci shoes, cashmere sweaters from London, wonderful skirts from Myricae on Via Frattina, Chanel belts, and she used Carvin's scent "Ma Griffe."

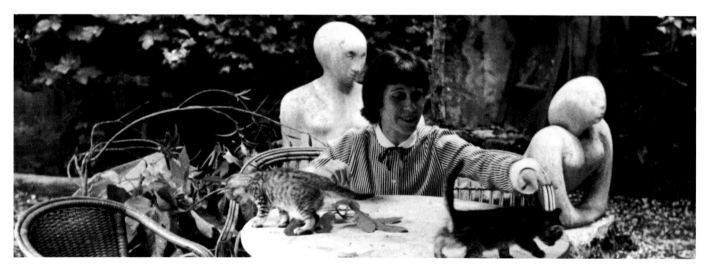

Gina always knew when there was going to be a sale in Rome. She also knew that Gucci gave a 25-percent discount to artists and intellectuals and would consider both of us to be in that privileged category. Our favorite Gucci handbag was a huge half-circle made of the finest pigskin dyed dark brown or black, with a shoulder strap of the red and green striped Gucci insignia. The bag carried almost everything we owned: address books, makeup, eyeglasses, notebooks, keys, and other necessaries of daily living. It could also accommodate all the accoutrements the average prostitute needed in her trade. I doubt if any of these "ladies" carried bags like ours; nevertheless, we called this bag a *cinq à sept,* literally translated as a "five to seven," referring to the hours of the early evening when men patronized "les girls" between leaving their offices and arriving home for dinner. I assumed that the term *cinq*

à sept was our own private joke, but one day in New York the strap on my Gucci bag broke, and I went into the Gucci shop on Fifth Avenue to ask if they had a replacement. The clerk, who had never been near Via Condotti in Rome, told me "Oh yes, we can repair your *cinq à sept* immediately." She used the term quite casually, and I then realized how universal the practice was (no pun intended).

Gina Franchina called me one day to say that the sale of sales was going on at Patrick de Barentzen, then the leading couturier in Rome, whose clothes had been featured in an issue of *Life* a few weeks before. In the fifties, Italian fashions were just beginning to receive worldwide acceptance. Like all couture houses, Patrick de Barentzen sold off its models at the end of the season. When we arrived, Gina was the first to spot the red and black chasuble and skirt that had been featured in *Life*. I found it irresistible and bought it for a huge amount of *lire*. As I write this, however, I have just figured out that, over its thirty years of use (I still wear this spectacular creation), it has cost me about $29.50 a year.

De Barentzen and I shared a passion for leopard. The pattern of its spots has fascinated me since I was a child. That isn't surprising, since I am a Leo who adores all cats, big and small. I use the leopard pattern in velvet and linen and can never resist an article of clothing printed in nature's most beautiful design. But leopard, ocelot, jaguar, lion, and tiger lover that I am, I could never wear the fur of a living creature.

Patrick de Barentzen's trademark was black leopard. It was very chic and distinctive. His boxes and wrappings were printed with black leopard markings. De Barentzen didn't wear furs himself, but he designed fabulous coats from the pelts of the black leopard. I happened to be in his

salon one day when he brought out a magnificent black leopard coat. I suppose I would have bought it had I not been a passionate animal lover and not lacked the fortune it cost. The garment was a precious work of art, so I knew that eventually somebody would buy it—probably somebody who knew nothing and cared less about endangered species.

The very next day, as I walked along the Corso, I noticed that a woman in front of me was wearing almost the identical coat. It was not as stylish as De Barentzen's but it definitely was black leopard—the real thing, not an

ersatz polyester version. The coincidence was too much for me to bear, so despite my shyness I approached this lady and, with a cautious "pardon me," commented that her coat was magnificent and a rare sight on the streets of Rome. Had she bought it here from Patrick de Barentzen? On closer inspection, I was disappointed by the way she looked: frumpy and touristy, wearing the obligatory rubber-soled walking shoes and one of those knit dresses advertised as perfect for traveling.

She answered me in a British-sounding accent, not London Mayfair or East End but either Australian or South African: "Bought it from what's-his-name? God no, love. I shot the leopard myself in Kenya!"

I used to take my cat for walks in the section of the Borghese Gardens opposite our apartment. I had an extra long leash, so that he could chew on the few blades of grass that sprouted here and there among the debris. And debris it was. People who had no way of disposing of garbage other than flushing it down their toilets would wrap their scraps of god-knows-what in neat paper packages and deposit them behind bushes or under trees. You had to watch your step as you walked through what should have been a "Garden of Delights" but was actually parlor, bedroom, and bath for some Romans and the best breeding ground in the world for some ants and maggots. At least the rat population was controlled by the battalions of cats who appeared for midnight suppers.

One day as I walked to a favorite bench I noticed that it was occupied by an old lady, a typical Roman house-wife. There was nothing unusual about her except that she held a long cord at the end of which was a chicken. No ordinary chicken, but a traditional chanticleer, who seemed to be enjoying himself immensely, foraging for worms and insects. We were quite a pair—I with a cat on a leash, she with a rooster. My Italian was not good; nevertheless, we had a marvelous conversation about life, the price of flour, and our respective pets. Signor Cock-a-doodle-doo lived on my new friend's balcony with his wife, a fat red hen who supplied the household with fresh eggs daily. I felt that our encounter would have made a marvelous scene in a Fellini film.

Exotic pets seemed to be the rule, rather than the exception, in Rome. Carlo Levi, the writer and artist, had a live-in crow, two poodles, and a large tortoise. Painter Renato Guttuso and his wife, Mimise, had more than one tortoise who wandered in and out of the rooms in their house, making it impossible to take a step without first looking down to see if one of those slow-moving reptiles was underfoot. I learned that the tortoises worked for their living by keeping the premises free of roaches and ants. The Guttusos fed them the freshest greens, flowers,

and vegetable delicacies for lunch, but their dinner menu of creepy crawly creatures was their own responsibility.

Cats and dogs were the normal household pets. During the fifties the most popular dog in Italy, especially in Rome, was the boxer. I imagine it was the macho appearance of this canine that made it a status symbol for the young men-about-town. A boxer and an Alpha Romeo convertible were irresistible enticements to young women of marriageable age. They saw in one package symbols of masculinity and wealth. I would watch the women watching the men as they sped through the roads of the Borghese Gardens on Sunday mornings. They unleashed their dogs, who jumped joyfully out of the cars, and then the boxers would follow their masters in a race of animal against machine until the exercise had exhausted them. The diet of dogs in Rome was much like their owners'—pasta, pasta, and pasta. The dogs seemed to thrive on this nourishment of starch, with an occasional bone thrown in for extra nutrition.

While the Italian government worked feverishly to rid the city of insects with massive doses of DDT, they did nothing about the cat population. Neutering and spaying of animals is anathema in Italy. The word *castrato*, even whispered, produces enough male emotion to start a civil war. The result is an overpopulation of cats.

Since a cat's gestation period is sixty-eight days and a female can have as many as six kittens, the same female might easily produce 120 kittens in her lifetime. I have seen tourist buses stop at the Forum, the Pantheon, the Colosseum, and the Largo Argentina to show the cat colonies as though they were attractions.

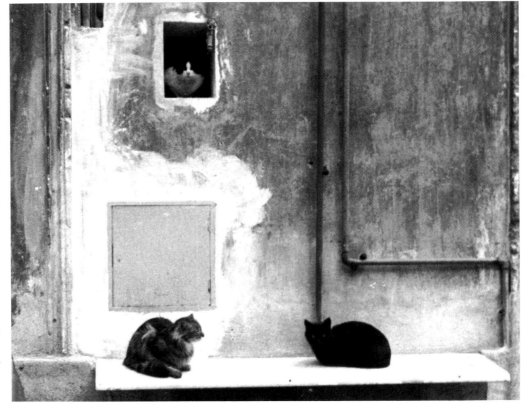

One day, wandering through the Ghetto of Rome, I realized that it was a time capsule of architecture through the ages. The Teatro di Marcello (Theater of Marcellus) was started by Julius Caesar and completed by Augustus, built to hold 20,000 spectators. It originally had three tiers of arcades and may have been one of the first shopping centers in history. Now its massive, crumbling ruins are an apartment house. In 1954 the Ghetto was functioning again after the war, but this time not to isolate the Jews. Medieval houses, Renaissance palazzos, and the remains of Roman temples were all put to good use as apartments and shops. A kosher butcher sold his wares in the entrance to a medieval tower. The best fabrics in Rome could be found spilling out into the street from a shop. Bolts and remnants from couturier collections, silks, velvets, linens, and luxurious brocades were there for the choosing. Another store was and still is famous for its porcelains, antique and modern—Ginori and even Spode—at discount prices. The clothing shops sold new and old clothes, and you could find laces, embroidery, costumes, and other treasures from the eighteenth and nineteenth centuries. Everyone I knew in Rome made regular trips to the Ghetto in search of the unusual.

Da Giggetto is a kosher restaurant famous for its artichokes prepared in olive oil and pan-fried until they are crisp. I admit that I didn't find them very palatable, but they are considered a delicacy and attract gourmets from all over the world. Jews visiting Rome who are looking for a kosher restaurant will be disappointed with Giggetto. It has none of the ethnic dishes familiar to Eastern European Jews. Fried fish is one of the staples here. It's very good, but unlike anything my grandmother made. The cuisine of Italian Jews has always been admired, however. There is an ancient Italian saying, *Vesti da turco e mangia da ebreo* (Dress like a Turk but eat like a Jew).

Not far from the Ghetto, on a small hill overlooking the Teatro di Marcello, is a field with two Corinthian columns from the Temple of Apollo. In the spring, the ground suddenly becomes a field of anemones. The anemone has always been my favorite flower. I have painted it and admired it. Since the blooms often have the blue, white, and red tricolor of France, it is a living symbol to me of Liberty, Equality, and Fraternity. It is said that the anemone was the flower Jesus meant when he said, "Consider the lilies of the field, how they grow."

Historically, the Jews first came to Rome after Jerusalem fell. In 1492, Spanish Jews fled from the Inquisition to find refuge in Rome. During World War II, monasteries and convents all over Rome hid Jews, but many became victims of Hitler's armies. A few notable Jews, such as Carlo Levi, were spared. He was exiled to a small

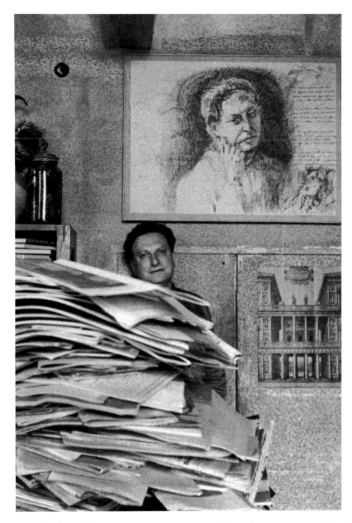

village just north of Naples. His experiences with the villagers and his life during the war inspired his book *Christ Stopped at Eboli.*

One of the greatest acts of heroism was organized by a Roman physician, a Partisan leader. The plan was to attack a detachment of German troops who were to pass through Rome in open trucks. The Partisan group waited until the trucks had passed and then threw explosives into the convoy.

Thirty-two of the German soldiers were killed instantly. In retaliation, the German command ordered ten times the number of men (plus a few extras) to be picked up at random on the streets of Rome. They ranged in age from boys of fourteen to old men in their eighties. These hostages were then taken to a cave at Ardea outside of Rome and shot. The cave was sealed and not opened again until after the war. As a memorial to the victims, the three hundred plus bodies were placed in bronze coffins and laid side by side with their photographs and names in a magnificent structure with only a roof above them. On the roof were two symbols: a star of David and a Christian cross. The entrance gates to the memorial, Fosse Ardeatine, were done by the famous sculptor Mirko (Mirko Basaldella), and visitors come daily to pay their respects. I have heard that people who lived near the site of this massacre heard the screams and the gunshots but were afraid to do anything about it.

Strangely enough, the physician who planned the attack was not honored as a hero after the war. Instead, he was ostracized by his friends and colleagues as a murderer of his fellow Romans. I saw him one day at Rosati's, ignored by everyone. He had aged considerably and had a face that reflected the sadness of a "man without a country." Romans do not forgive easily.

MILAN

Milan has been called the only European city in Italy. The Milanese claim that anyone who lives two miles south of Milan is a Neapolitan. The "ultra-modern" concept in architecture and furnishings began in Milan. Architect Gio Ponti designed a set of stainless steel flatware that I have and use. Eventually I will give it to the Museum of Modern Art in New York as an example of the movement away from classical design in common utilitarian objects.

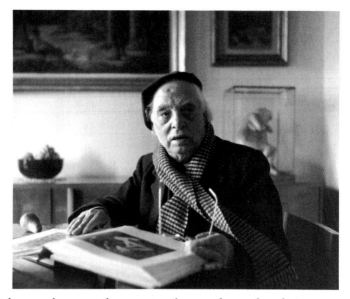

It was Gino Severini who suggested that we go to Milan to photograph a group of Metaphysical and Futurist painters who lived there and were his friends. They were quite old at the time, and, although we had already photographed De Chirico in Venice, we wanted to meet the others: Carlo Carrà, Mario Sironi, Arturo Tosi, Renato Birolli, Giacomo Manzù, and Marino Marini. These last two were much younger than the others but they had carved a definite niche for themselves in the annals of Italian art.

The Milanese artists had an interesting history. When they were young, a group of them became dissatisfied with the lack of development in the various schools of academic painting and the superficial attempts at impressionist work elsewhere. On February 11, 1910, they issued a manifesto stating their ideas about a new direction for art and challenging the status quo of art criticism. They called their movement Futurism, a term borrowed from their friend, the poet Filippo Marinetti, who had set forth his own Manifesto of Futurist Poetry a year before. In the four years before World War I, the Futurist painters and poets were castigated as perpetrators of a decadent new art. Two of the innovators who had signed the original manifesto were Carlo Carrà and Gino Severini. As they matured, these men and their courageous colleagues abandoned Futurism for an art derived from Cubism. The Milanese painters we met all experimented with concepts that reflected the mechanization of the world around them.

Carlo Carrà, then quite elderly, still had a spirit of adventure and an indestructible sense of humor. Mario

Sironi and Arturo Tosi, once artistic rebels, had mellowed with age but were still painting, experimenting with form and color. In unison, they applauded the work of the younger painters and sculptors, the contemporary canvases of Alberto Burri and Afro, the sculpture of Pericle Fazzini, and the marvelous diversity of Marino Marini.

Mario Sironi telephoned Marini to suggest that he receive us and be photographed by Sandy. The day we arrived at Marini's apartment, he answered the door with his hand over his right eye. He spoke excellent English and apologized for his embarrassing predicament. He explained that he had been hanging a larger-than-life wooden figure of Christ, a fifteenth-century sculpture, on his studio wall when suddenly a part of Jesus had hit his eye. With typical Milanese humor, Marini attributed this assault by Christ as a warning about his behavior. We laughed with him, but I knew that a photograph of this handsome, talented man with a black eye would be unthinkable. I hesitated a minute and then asked Marini if I might take the liberty of concealing the discoloration. He begged me to try, and I went to work with my Elizabeth Arden compact. The powder matched his skin perfectly, and the photograph showed no signs of his unfortunate encounter with his savior.

We also met Giacomo Manzù, who insisted that the photograph Sandy took in his studio show the old ballet slipper that hung on his wall. It was his good luck charm, he said, but I didn't have the courage to ask him why.

Being in the presence of these men took us into the living world of Italian art history. If we could have time-traveled back to another age, my husband would have been able to photograph Michaelangelo, Raphael, and Titian. Unfortunately for them, we were born too late.

VERONA / MARIA CALLAS
Most people go to Verona to see Juliet's balcony, the Roman arena, the art objects in the cathedral, and the other treasures this historic city offers, but we went to Verona to photograph Maria Callas. Sandy got the assignment from Irene Brin, the *Harper's Bazaar* editor in Rome.

"Where do we find her?" my husband asked Brin.

"I really don't know. Somewhere in Italy. You'll have to do the research on that."

The mystery was solved by our housekeeper, Madellena. Like all Italians, Madellena was an opera-star

groupie. The most obscure member of the chorus had no secrets from her. Baritone, tenor, bass, or soprano, spear carrier or diva, all unknowingly shared their lives with Madellena. Her information about Maria Callas was immediate and accurate. She dialed the operator in Rome, asked for Verona information, and in a few seconds gave me the number of Maria Callas's home.

I dialed the Verona number myself, because my husband was afraid the phone might be answered in Italian or French or perhaps Greek. I assumed Madame Callas was Greek. At the other end of the wire stretched across Italy I heard a woman's voice say "Hello?" in unmistakable Bronx English. I asked for Madame Callas, and the voice assured me I was speaking to her, in the New York intonation so familiar to my ears.

I identified myself, and she graciously extended an invitation for us to come to Verona the next day. She volunteered to make the hotel reservation for us, and when I mentioned that we were bringing our cat she assured me that there would be no problem, because "if Callas says there will be a cat with her guests no hotel would dare to refuse." She gave us the name of the hotel and told me to call her when we arrived.

The drive from Rome to Verona is quite long. We left early in the morning and arrived in Verona at about four o'clock that afternoon. It was a hot summer day, but the room Maria Callas had arranged for us was cool and rather luxurious by nineteenth-century Veronese standards. The only twentieth-century accessory was a telephone, which we used at once to call her. Signor Meneghini, her husband, spoke to me in French and informed me that his wife was at Elizabeth Arden but wanted us to meet her for dinner at nine o'clock at the restaurant on the square. Our excitement mounted as we waited for the hour to arrive. We wandered through Verona and stared at Juliet's balcony. We quoted some lines from *Two Gentlemen of Verona,* bought some *fegato* (liver) for our cat, Louis, and couldn't resist a mimosa-yellow cashmere scarf, reduced for clearance in a July sale.

As we approached the restaurant, we saw a couple on the terrace greedily cutting into their *osso buco,* sipping wine between bites. Actually I had no idea what Maria Callas looked like in private life. I knew her as Mimi in *La Bohème,* as Tosca, as Norma, but never as an overweight middle-class housewife. The man with her was, of course, Signor Meneghini. He looked old enough to be her father and ominous enough to be a member of the Black Hand Society. Callas saw us and asked us to join them. After introductions, during which Meneghini continued to eat, we sat down at their table. Sandy and I glanced at each other, silently questioning whether we had misunderstood

the invitation to have dinner with them. Meneghini brusquely asked us to order something like cold chicken so no time would be lost. That cold chicken was all I ever learned about Veronese cuisine. When Meneghini asked for separate checks for us, I knew that my instincts about his character were correct.

Maria Callas and I talked during the meal. She mentioned that she was an actress as well as a singer and that she intended to lose a lot of weight. She did lose that weight years later, and became a magnificent woman, a true *diva sublima*.

After dinner, they asked us to come to their apartment for a drink. I walked with Meneghini and Sandy with Callas. They talked in English, but I was left to converse with him in French. He gloated over the fact that, since Verona had been bombed by the Americans during the war, he could now buy property that he coveted at a very low price. It was a ghoulish attitude and made me wonder what position he had held in Fascist Italy.

Callas and I had an opportunity for some girl talk when we went upstairs, and she showed me her new wardrobe. In a few minutes she seemed like an old friend, but that ended as soon as we rejoined Meneghini. He announced that Callas and he had to leave Verona for Rimini early the next morning.

"What about the photographs for *Harper's Bazaar*?" asked my husband.

"You will come to Rimini and do them there."

It sounded so casual, but Rimini was more than 150 miles from Verona. It meant packing bags and equipment and cat and doing another petrol and oil check on our Mercedes.

"We leave at seven in the morning. Madame Callas has to rehearse with Giuseppi di Stefano, who lives in Rimini. Don't worry. You will find a nice hotel there, right on the sea, and you will call us in the afternoon." Meneghini issued orders; Callas was silent and more than slightly embarrassed. We said good night and promised to call them in Rimini the next day.

We arrived in Rimini only to discover that the Di Stefano estate was in Rimini Marina. On a July weekend, Rimini Marina bore a resemblance to Coney Island in Brooklyn. It was littered with small *pensioni,* but all of Italy was on vacation, and there was no room at any of them if you hadn't made a reservation three months in advance. To make matters worse, we were Americans and traveled with a cat cum litter box. In low-grade pidgin Italian, I explained that we had come to be with Maria Callas, who was staying with Di Stefano. That was enough to get

us the last remaining room in a third-class *pensione* where the other guests were transit workers from Rome and their families.

I telephoned the Di Stefano estate ten times the next day. Somebody (certainly Meneghini) gave me ten excuses, ranging from "Madame is at the beach" to "Madame is lunching." Finally, I decided to go directly to the Di Stefano sanctum sanctorum and confront Meneghini. At the gatehouse to the estate I was met by a security guard.

"I demand to talk to Signor Meneghini. Ask him to come out," I said.

Meneghini did appear, and from his side of the gate he told me that he would not under any circumstances allow Callas to be photographed. His excuse was that she hadn't brought the proper gowns with her. I explained that gowns didn't matter; my husband wanted only her face in the most informal portrait, and it was for a full page in *Harper's Bazaar.*

He refused even that. Although Callas had already agreed, his decision obviously superseded hers.

We left Rimini for Rome, and when we told Irene Brin what had happened she was furious. She vowed that *Harper's Bazaar* would never publish a photograph of Maria Callas unless it was one in which she looked obese and unattractive.

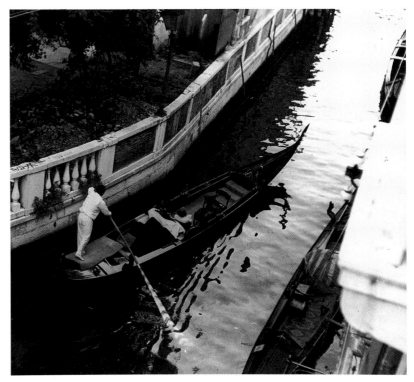

VENICE One day in Paris I shared a seat on a bus with a very talkative French woman. In the few minutes between the Galeries Lafayette and the Gare St. Lazare, she told me that she had just returned from Italy. Rome, she observed, was "very interesting." Florence was "so so."

"What about Venice?" I asked.

"Venise, c'est une ville comme les autres villes." (Venice is a city like any other city.)

Her comment was ridiculous. Venice is unlike any other city. We went to Venice with some of our Roman friends, painters whose work was being exhibited at the Biennale Internazionale d'Arte. At this grand art gathering, paintings and sculptures from all over the world were shown, and the Italian artists had their own gallery. The only painter who would not exhibit with his countrymen was De Chirico. He was no longer young, and he had rejected the earlier work for which he was famous—metaphysical landscapes with endless arches diminishing into vanishing points. His new paintings were Rubenesque portraits matted in red velvet, surrounded by baroque gilded frames. When we photographed De Chirico that day in his own rented gallery, he refused to sit near any of his metaphysical paintings and tried to make sure that they were not within the range of Sandy's camera. Nevertheless, we managed to include a glimpse or two of the wonderful paintings that had been conceived under the Futurist and Metaphysical banners early in the century. I saw in De Chirico a sad and lonely man who seemed to reject his past.

One day at the Florian café in the Piazza San Marco, our friend the artist Giuseppe Santomaso told us that the towering Campanile had collapsed and fallen across the square in 1902. He was born on the fifth anniversary of the disaster, and he felt it was a good luck omen. Italians have peculiar superstitions about good and bad luck. It seemed inconceivable to me that a tower that had stood for centuries should suddenly fall to the ground. But Venice is unpredictable. It is made up of many small islets surrounded by the waters of a lagoon in the Adriatic. Ferocious tides often inundate Venice, disturbing the sandlike foundation of its historic buildings. I always view the Campanile with a suspicious eye, wondering whether it will fall again to commemorate somebody else's birthday.

Venice is a wonder of the world. Today as you look at the Grand Canal and the spectacular sunsets reflected in the water, it is almost impossible to believe that, centuries ago, Guardi and Canaletto saw the same seascape. Later the English painter Turner recreated Venice as he saw it with his palette of yellows and umbers. In more modern times, the Austrian painter Kokoschka is known for the visions of Venice he put on canvas. My friend Arbit Blatas now lives in Venice and has his palette arranged for the colors of the city. His works are produced with love and capture the subtlety of light and shadow on Venice's ancient landmarks. His wife, opera star Regina Resnik, heads the Save Venice committee and devotes much of her time to keeping its architectural treasures from disintegrating under the influence of time and tide. Madame Resnik recently produced a

documentary film on the old Ghetto in Venice, which has three synagogues that date back to the sixteenth century.

I will never forget the day I made an absolute fool of myself in Venice. I had always wanted to own a Fortuny dress. As a young girl I had been transfixed by the sight of these wearable works of art in the window of the Fortuny shop on Madison Avenue in New York. At first I was too young to wear one, later too poor to buy one. They remained a symbol of the unattainable until I realized that Venice was their place of origin.

The time had come. I was in Venice, and the problems of age and cost no longer stood in the way. The *portiere* of the Luna Hotel where we were staying assigned a young bellboy to escort me to the Fortuny palazzo. We crossed bridges and walked through alleys for about fifteen minutes and arrived finally at the palace of my dreams. I had no idea of the *embarras de richesses* I was about to see. I was led into a large hall lined with carved antique chests. Each of them contained a different color of Fortuny gowns in graduated tones and shades. There were blues from the palest cerulean to the deepest midnight, violets from delicate mauve to vibrant purple, reds from peachy pinks through corals to garnets and carmines. The gowns of finely pleated silk lay nestled in the chests twisted like skeins of yarn—they were impervious to wrinkling or crushing. When you owned one it had to be kept in a tube and never, never see the outline of a clothes hanger.

A Fortuny dress endowed the wearer with an aura of individuality. Women who owned Fortuny dresses wore them forever. You would see them at opening nights in New York, at elegant dinners in London; a woman wouldn't hesitate to wear the same dress ten times a year, year after year. These art objects have become so rare now that, if one could be found, it would cost as much as a trip around the world first class.

There I was in a dressing room in the Fortuny palazzo being fitted into a mauve pleated silk. I looked like a Greek goddess, a Tanagra figurine, an Isadora Duncan; by some mysterious transformation I was no longer myself. The dress had to be shortened for me and then expertly re-hemmed with gossamer gold thread, one of the Fortuny hallmarks. I emerged from my dream state long enough to ask the price of the gown. The *venditrice* answered in British-accented English, "It will cost Madam $275."

There was a currency regulation in Italy at that time specifying that all purchases had to be in *lire*. This was because there was a booming black market in dollars. The legal exchange rate at the time was about 900 *lire* to the dollar, but you could get as much at 1,500 on the black market if you had greenbacks (less for traveler's checks and

even less for personal checks, although still substantial amounts above the official rate). The law was strictly enforced, when a violation was spotted, and both parties to a sale risked penalties. Nonetheless, shops were eager to get dollars, which could increase their income.

Hearing the price quoted in dollars suddenly made me furious. Sandy and I were living and working in Italy, being paid in *lire,* making all our purchases in *lire,* and this salesperson thought she was dealing with a naive

American tourist who wouldn't realize what the store was up to.

"Dollars?" I said. "How dare you quote the price in dollars. You know as well as I do that is against the currency regulations. It is an offense for me as well as Fortuny to do business in dollars." Besides, I didn't have any.

As I uttered these words, I stepped out of the dress and out of Fortuny's. I followed the bellboy back to my hotel, immediately regretting every moment of my high-flown outrage. Now, thirty years later, I could still be wearing my Fortuny dress if I hadn't been such a law-abiding idiot.

Riding in a gondola always made me regress to babyhood. As I floated through the Grand Canal with a gondolier behind me, gently steering his delicate craft through the water, I felt as though I were in a baby carriage being wheeled and gently rocked by my mother.

One of my friends asked me why all gondolas were painted black. I had no idea, but I was just as curious as my friend and asked everyone I knew in Venice. My research was successful. A friend of a friend who was an amateur historian gave me the details. During the sixteenth century, Venice was a madhouse of extravagant luxury. The nobility had balls and carnivals; Casanova and his ladies spared no expense to clothe themselves in the rarest silks and furs. In 1562, the government issued a "sumptuary" law (like our blue laws in this country) limiting expenditures. Gondolas were cited as primary examples of exorbitant ostentation. They were richly ornamented with color, gold leaf, and magnificent silk cushions and canopies—the ultimate in extravagance. The new law pro-

claimed that all gondolas were to be repainted a somber black—except those belonging to the doges and government officials. The black gondolas, in my opinion, add just the right touch of elegance to the flamboyance of Venice.

I recently learned these facts about gondolas—information one doesn't think of while being rowed through the canals. A gondola is thirty-six feet from prow to stern, six feet wide at the center, and weighs half a ton. It is constructed with eight different kinds of wood, selected to contribute to the buoyancy and strength of the craft. Each gondolier has his boat designed to accommodate his height, weight, and balance. He always rows from the same side, with intricate turns and half-turns of the wrists to maneuver correctly through the crowded canals. A gondola builder can produce only four or five a year, each constructed by hand in the traditional way, from the use of the ancient molds to the application of the black paint.

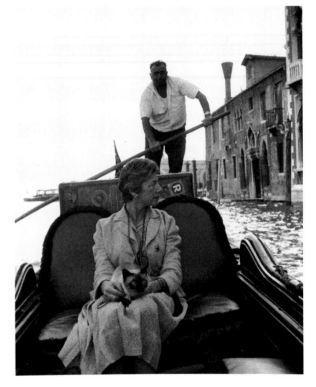

BORDIGHERA One summer we spent two weeks in Bordighera on the Italian riviera of the Mediterranean. During World War II the Germans had occupied the town and built bunkers along the beach next to the casino and theater. Of course, the German installations became targets for Allied bombers, and in no time there was nothing left along the beach but ruined skeletons of the buildings.

We were staying at a *pensione* with a beautiful garden in which a huge avocado tree was weighted down with fruit. I asked the manager of the *pensione* why she didn't use the avocados in her salads.

"Those? You can eat them? I thought they were poison," she explained.

I showed her how palatable they were, and for the next two weeks everything we ate was garnished with green slices. (The manager herself still refused to eat them, however.) I can't figure out how an avocado tree grew in Bordighera. Avocados were quite rare in Europe at the time. The only source of this exotic fruit was Fortnum and Mason's in London and the price was rather exorbitant, since the avocados had to be imported from California.

One day our charming landlady informed us that the town was going to have a great celebration. High-ranking Vatican officials were coming to celebrate the return of the remains of a local saint who had been buried in Turkey for 400 years. There was great rejoicing all over Bordighera that day, but the crowning event was to occur after dark, when a magnificent fireworks display would be held near the water. The best vantage point to witness the spectacle, we were told, was a little hill above the beach. So we drove our car up to this spot, following the rest of the town. We all waited for the sun to go down and darkness to set in, meanwhile consuming mounds of *gelato* (ice cream) and gallons of chianti. It was a joyous occasion until the fireworks began. Then, to the sounds of gigantic explosions, the red flares of starbursts illuminated the ruined buildings, and the war seemed to come back to Bordighera. Present reality vanished, leaving only the past, the memory of the bombings that had terrorized the town. One by one the motors started, and within a few minutes our car was the only remaining vehicle. I understood the traumatic effect the fireworks had. The illusion had rekindled old fears and triggered a mass exodus for shelter.

PERUGIA AND TODI

When I was about thirteen, I suddenly took an interest in Italian men. I had known many Italian men during my childhood in Brooklyn, but they were the anonymous deliverers of ice, menders of shoes, vendors of fruit, and fathers of a few of my schoolmates. There was no allure about these males—they were men like other men. It was Mr. Pisani, my piano teacher, who changed my outlook.

I had had a series of piano teachers from the age of nine. There was Mr. Sperl, who had the credentials for teaching children, but one day, while I was playing "Spinning Song," old Mr. Sperl reached under my dress with his right hand while his left hand beat the rhythm out on the piano top. Good-bye, Mr. Sperl. Next came Mrs. Schwartz, who couldn't understand why a nine-year-old could not play Chopin—and didn't even know who he was. Then there was Miss Charlotte E. Mason's Conservatory of Music. Miss Mason used the Montessori method of teaching, which left all of her students bewildered when they saw the actual sheet music and realized that they were playing Rachmaninoff.

During my first year in high school, my music teacher was Mr. Pisani, and he was every girl's dream of a

romantic Italian lover. He was employed by the New York Board of Education, but he gave private piano lessons at his home as well. I had never begged for piano lessons before, but I convinced my mother that I would become a devoted daughter, clean my room, run errands, and practice two hours a day, if only she would agree to lessons with Mr. Pisani. She finally did agree, on the condition that she be present at every lesson. My mother didn't trust men with mustaches, especially if they were Italian. My mother and I arrived at Mr. Pisani's house, an old brownstone, and were led into his parlor. Not only did Mr. Pisani kiss my mother's hand but he had also left a beautiful red rose for me on the keyboard of his Steinway baby grand. These chivalrous gestures, unknown by American women, charmed my mother into accepting Mr. Pisani as my teacher. But she never left me alone in that parlor with him.

After Mr. Pisani came a series of fantasies about Rossano Brazzi and Marcello Mastroianni, the prototypes of the Italian lover. I later discovered that Italian lovers come in all shapes and sizes. Only an Italian taxi driver can make you feel as though you are the most desirable woman in the world. One afternoon my sandal maker let his hand roam from my fingertips to my clavicle, whispering all the time *"Vengo sua casa"* (I will come to your house). He never had a chance, because I delivered a fast stab into his southern hemisphere with the point of my umbrella. I suppose the beautiful sandals he made for me are still sitting in his stock room.

I remember clearly the time I took a train from Paris to Perugia to meet my husband, who was working on a film with Peter Ustinov in Todi, a small town about fifty miles from Perugia. I assumed that Sandy would be at the station in Perugia to meet me. I had my luggage ready, but when I looked out of the train window there was nobody waiting for me, no husband and no car from the film company. The conductor informed me that there were two Perugia stations and suggested that my husband might be at the one five miles farther on. When we reached Perugia number two, the only living creature in sight was a contented horse chewing on some sunburned shrubs. Since the next station was Assisi, a half-hour away, I decided to get off.

I must have been a pathetic sight standing in that woebegone rural station, a thousand miles from nowhere, because a gentleman whom I'd seen on the train and who had also gotten off at Perugia number two suddenly came toward me and asked if I needed assistance. I told him I wanted to hire a car to drive me to Todi. Could he help? He said he was going to Todi too, so we could travel together and share the expense. It seemed like a wonderful idea. In no time my gentleman benefactor had found a vehicle with a driver who volunteered to chauffeur us for about

$25. I got into the car with my new friend and our luggage, and soon we were driving through hill and dale toward our destination.

About a half-hour into the journey, my traveling companion cleared his throat and asked if I were afraid to be with a stranger. The idea hadn't occurred to me, but when he mentioned it I began to feel uneasy. He was right. What was I doing in a car with a strange man who might be a rapist, a kidnapper, a terrorist? When the expression on my face showed my newly awakened suspicions, he revealed his identity.

"Signora, I must ask you to forgive me for not telling you before that you are perfectly safe riding with me. I am in civilian clothes on vacation, but I am a member of the *carabinieri*. My family lives in Todi, and I have four children."

The *carabinieri* are a part of the Italian state police, but not ordinary policemen. They parade, or rather stroll casually, through the streets of Italy in their elegant decorative uniforms, appearing at all formal state functions. Tourists regard them more as tin soldiers or comic opera characters than as real police officers. The city police, or *questure*, in their drab uniforms attend to any infringements of law, from parking at a red curb to murder. They keep their faces expressionless and their personalities indistinct, yet to most people a confrontation with a *questura* is a serious matter.

The law requires that every foreigner living in Italy report to the *questure* every three months to receive a permit of residence *(permesso di soggiorno)*. Those who do not appear must beware. Leaving Italy one time I was asked to show my "papers," which included passport and the permit stating the dates of renewal of permission to remain in Italy. For some unexplained reason I had forgotten to report to the police for a renewal. I considered this the most minor of infractions. I did not steal an Etruscan figure from the Villa Giulia. I had no cocaine on my person. I was not wanted for espionage. I had just forgotten to register.

I was threatened with detainment, which would have meant missing my plane to Paris. At that moment I resorted to a shameless but most valuable ruse to get anything you want from the police. I shed a few crocodile tears and announced that I was pregnant. I was as far from being pregnant as Grandma Moses, but just using the word changed the attitude of the officials immediately. I was escorted to my plane by two policemen. One even carried my handbag. The other carefully held my arm with a grin on his face. To this day I don't know if they knew I was

joking or if the imminent birth of a child brings out some primitive protective instinct in Italian men. They left me with an atonal duet of "Ciao Ciao, Bambina," the most popular song in Italy at the time. And very apt, too.

CIAO, ITALIA! I did not throw a coin into the Trevi Fountain when I left Rome in 1962. I wanted to remember Italy in my own way, and I knew that my experiences there could not be repeated. My memories are vivid of the friends, the intimacy, the comradeship, the interests we shared. I look back to that beautiful autumn day in Rome when Aldous Huxley escorted me to the Villa Giulia for a lesson on Etruscan art. I know that never again will Bulgari's restring my common cultured pearls for $7.50. Nor will I have expensive leather collars custom made for my cat at Battistoni on Via Condotti. I regret not buying the red leather shoes with heels made of brass rooster's feet or the necklace of gold laurel leaves I admired in a jeweler's window. I sometimes dream of the marvelously textured *gelato* and the elegant way cherries were served in restaurants, six tied together with raffia, accompanied by a bowl of ice water in which you washed and freshened them.

I treasure having met the great Italian painters of this century, who declared, as angry young men, that Futurism must replace classicism. Those still young when I met them are old now. I had tea with Carlo Carrà; Mario Sironi kissed my hand; Arturo Tosi had dinner with us; Giorgio Morandi charmingly offered me one of the white porcelain vases that figure in his still lifes; Gino Severini, his wife, and his daughters were my treasured friends; Giorgio de Chirico begrudgingly let Sandy take his picture holding our cat.

The *dolce vita* ended on the night my husband died in the Inghilterra Hotel on Via Bocca di Leone in Rome on March 5, 1962.

DAILY LIFE

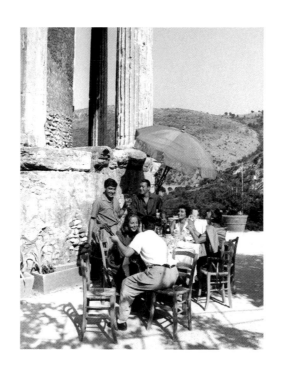

In Naples, a man selling slices of sumptuous melons brandishes a large knife that cuts wedges of precise sizes, depending on the amount of *lire* his customer is willing to spend. His business prospers during the hot summer, but eventually the melon crop will go to seed, and seasonal weather will force him to retire until the following year.

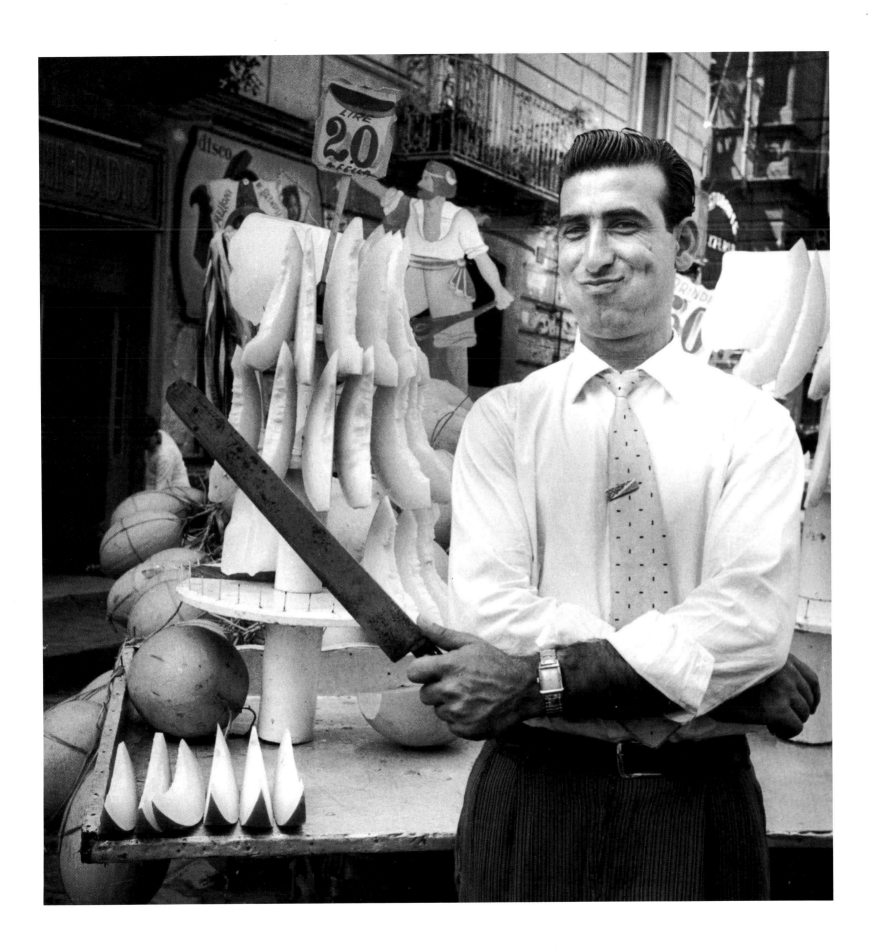

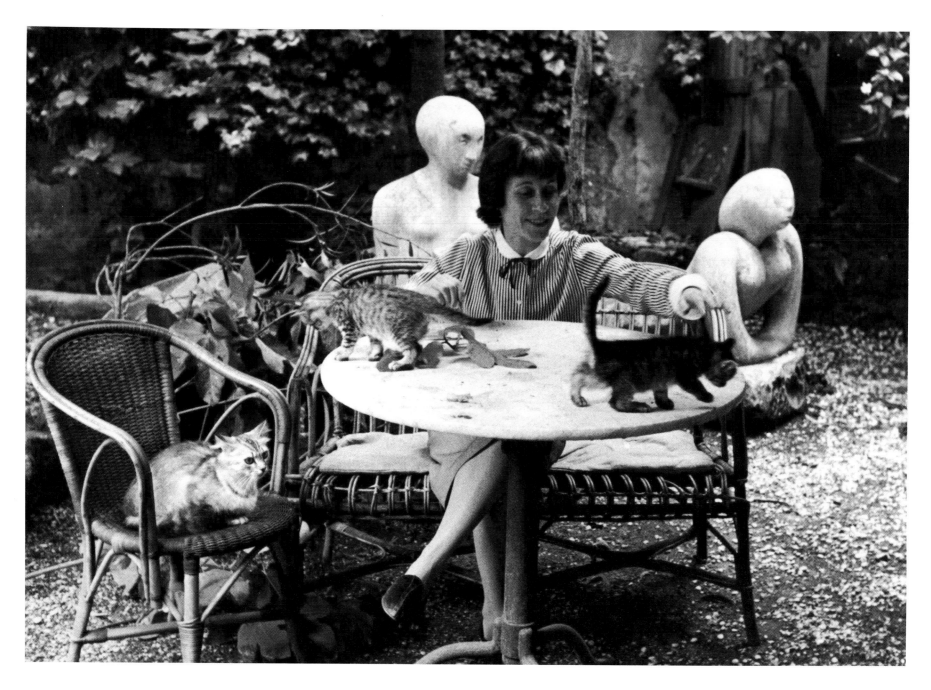

Above: Gina Franchina, artist Gino Severini's daughter, on the terrace of her apartment with her kittens. The building and the steps to her apartment were used in the film *Roman Holiday,* making it a tourist attraction.

Right: Our housekeeper, Madellena Vespignani, with our cat, Louis. Madellena was our nanny, confidante, secretary, friend, and the world's greatest authority on opera and its backstage gossip.

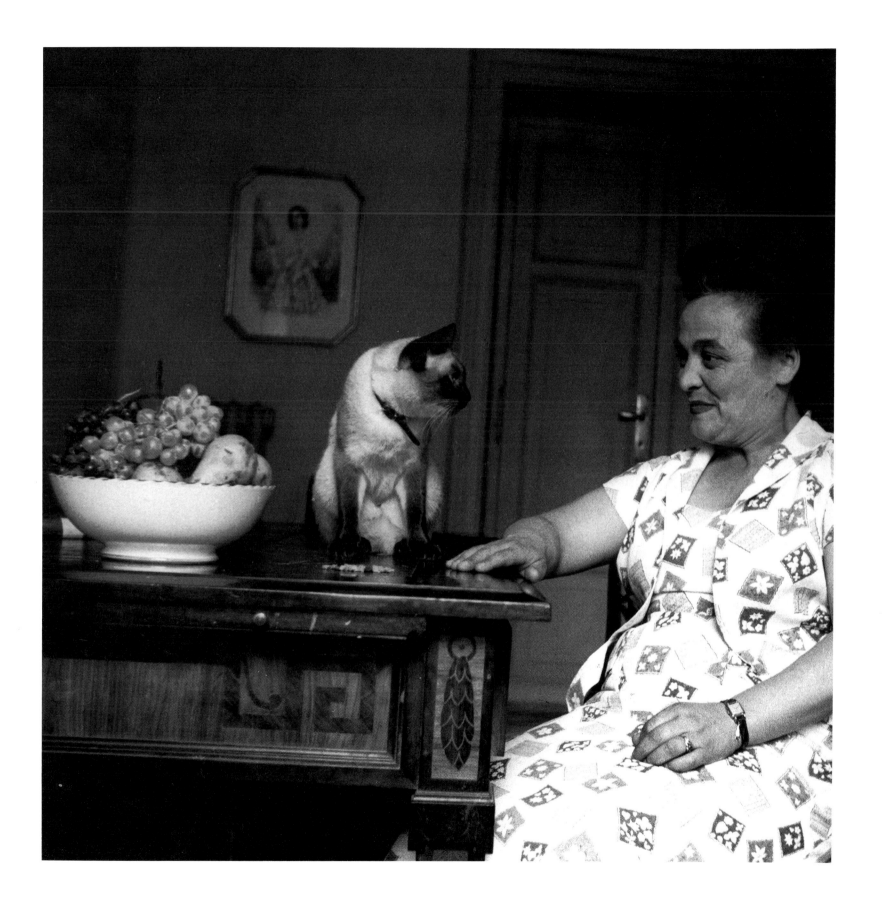

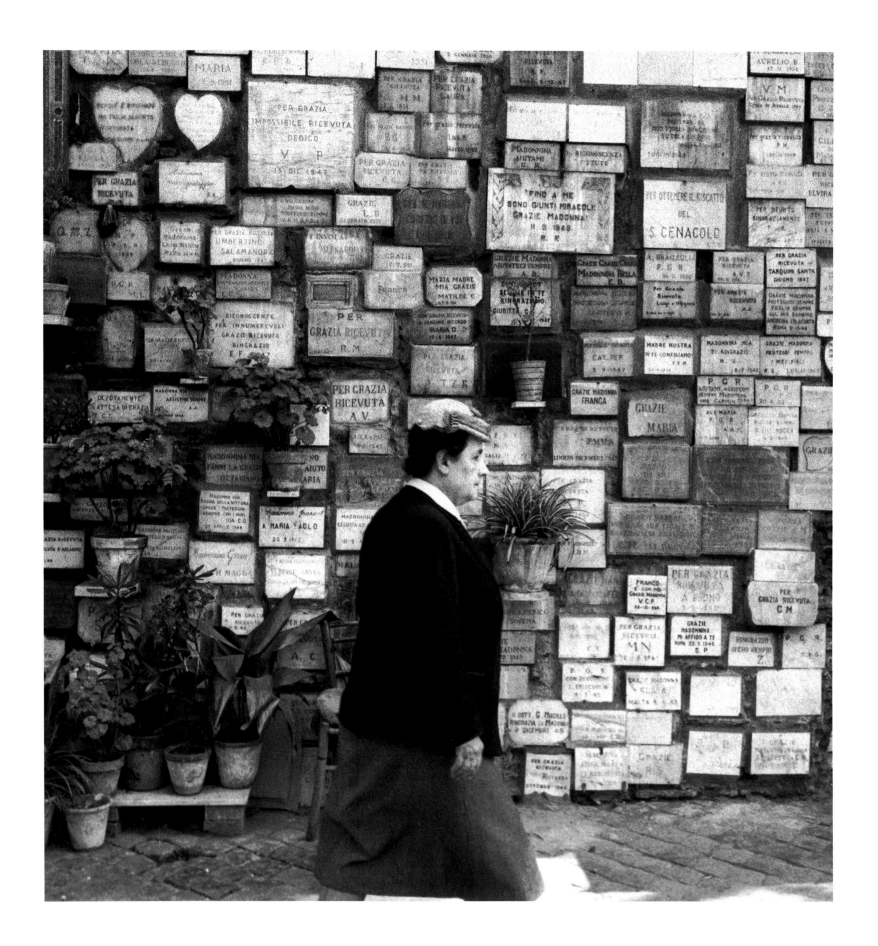

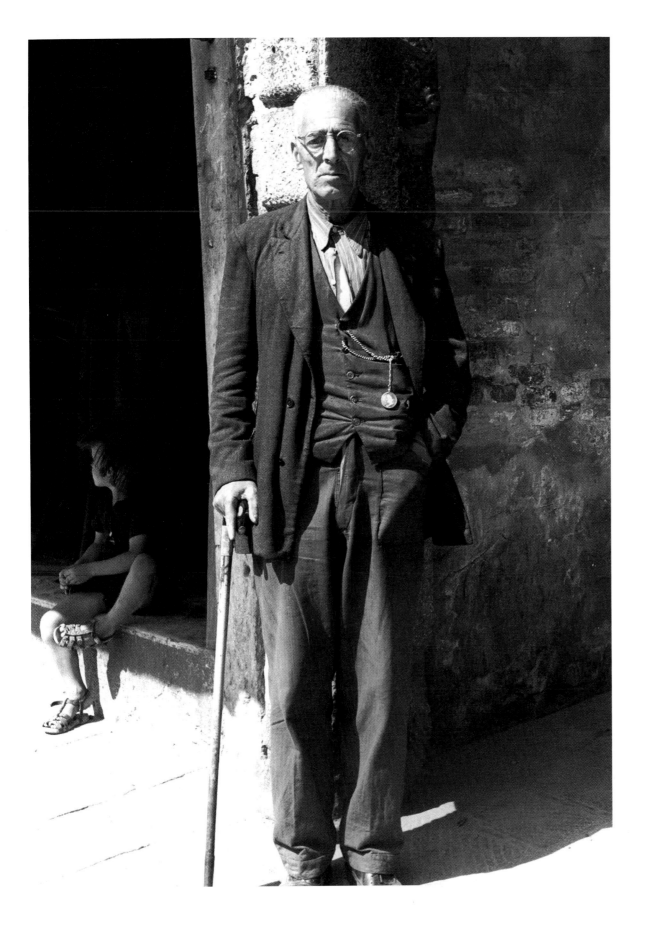

Left: A wall in Rome reserved for the exclusive use of people who want to thank the Holy Mother for some miracle in their lives. The plaques are inscribed with individual problems that have been resolved by the power of prayer.

Right: In the Venetian Ghetto, the guardian of one of the ancient synagogues is proud of the responsibility of preserving its dignity and historic significance.

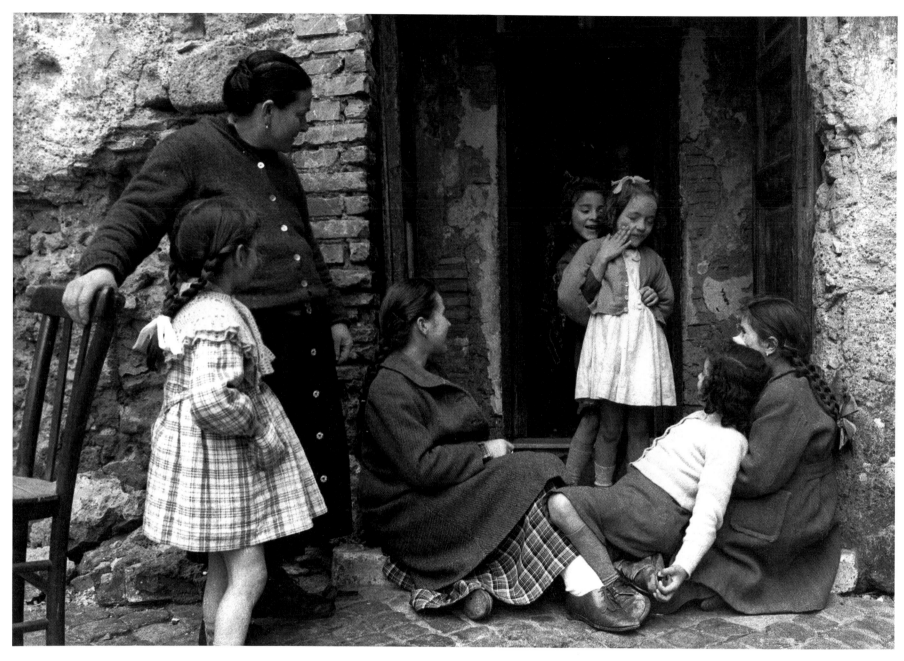

ITALY
'50s

In a back street in Naples two girls amuse their friends
with a pantomime game, one acting as the arms of the
other. The same gestures can be seen around the world,
from New York to Timbuktu.

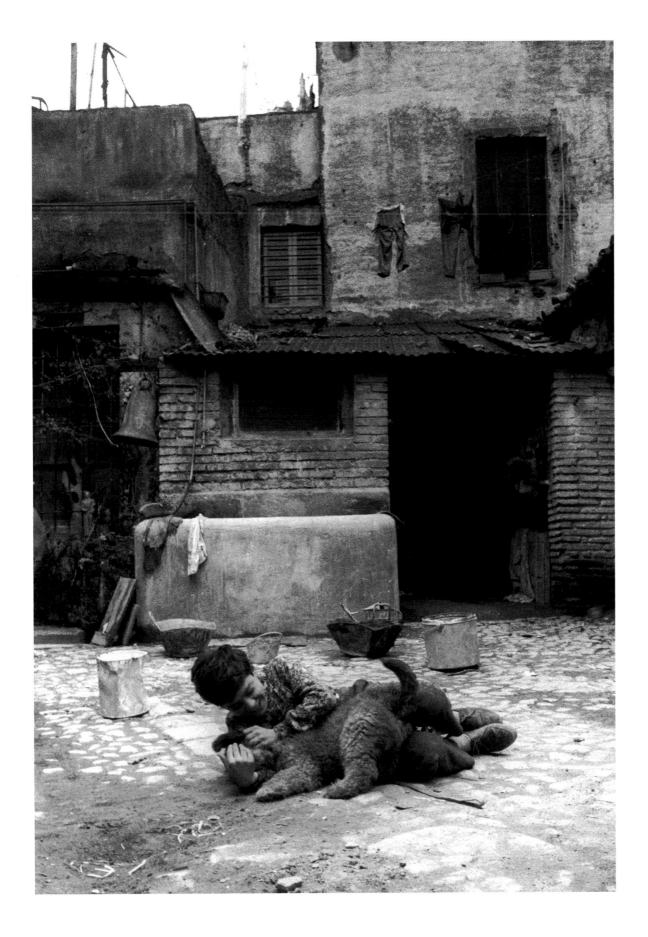

A large dog and a small boy find mutual joy in an encounter somewhere in Trastevere. Their little game mimics the classic battle between a gladiator and a lion in the Colosseum.

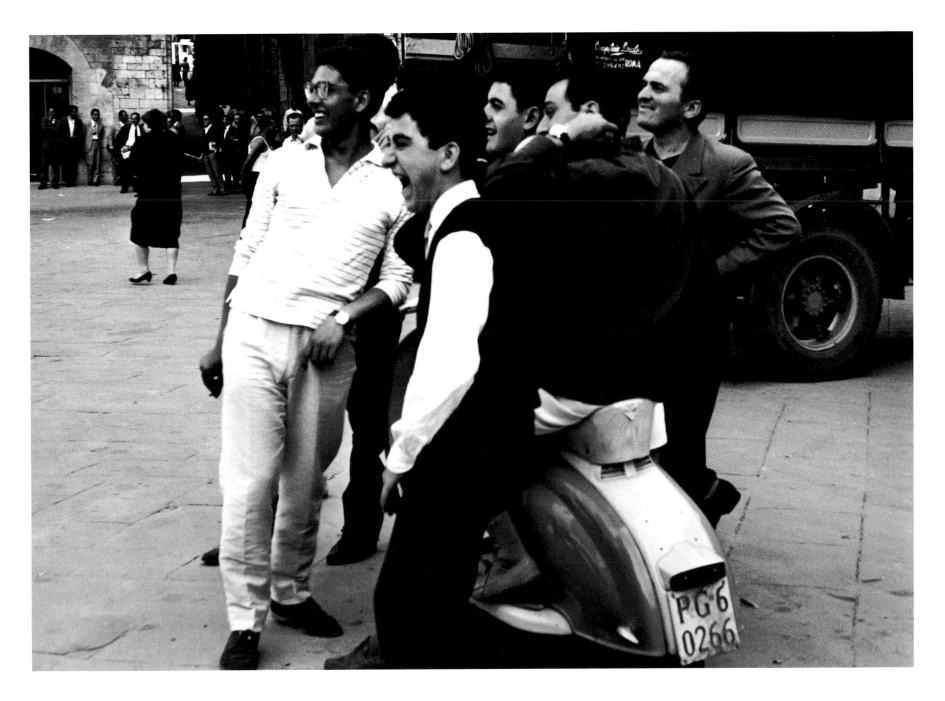

ITALY
'50s

Above: A group of young men from Perugia are amused at the antics of the actors in Peter Ustinov's film *Romanoff and Juliet,* which was made in Todi, not far from Perugia.

Left: A couple have come a long distance to Frascati for the carnival, dressed in the costumes of their region but riding on the symbol of Italy during the fifties—a Vespa.

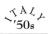

A boy standing on a bank of the Tiber in the old Roman Ghetto personifies the spirit of the Italian Jews who came to Rome after the fall of Jerusalem. He proudly displays the victory symbol, a universal sign of resistance to oppression.

Facing page: In an abandoned Roman garden in Ostia Antica, a young girl stands near an ancient fig tree whose fruit may have been eaten by Claudius.

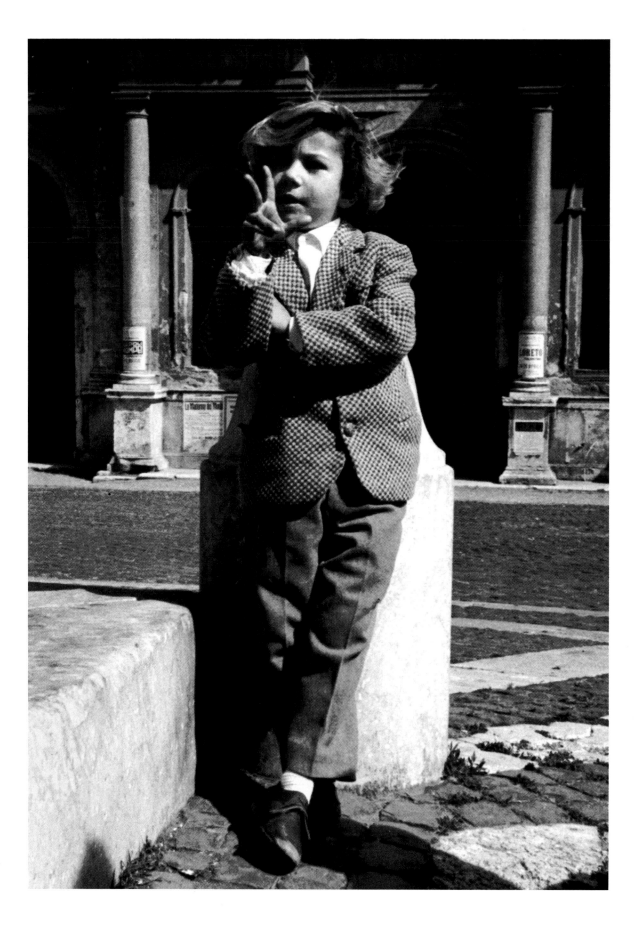

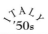

The gondolas in Venice serve as delivery trucks as well as taxis. The wine consumed in Venice comes from outlying districts with productive vineyards.

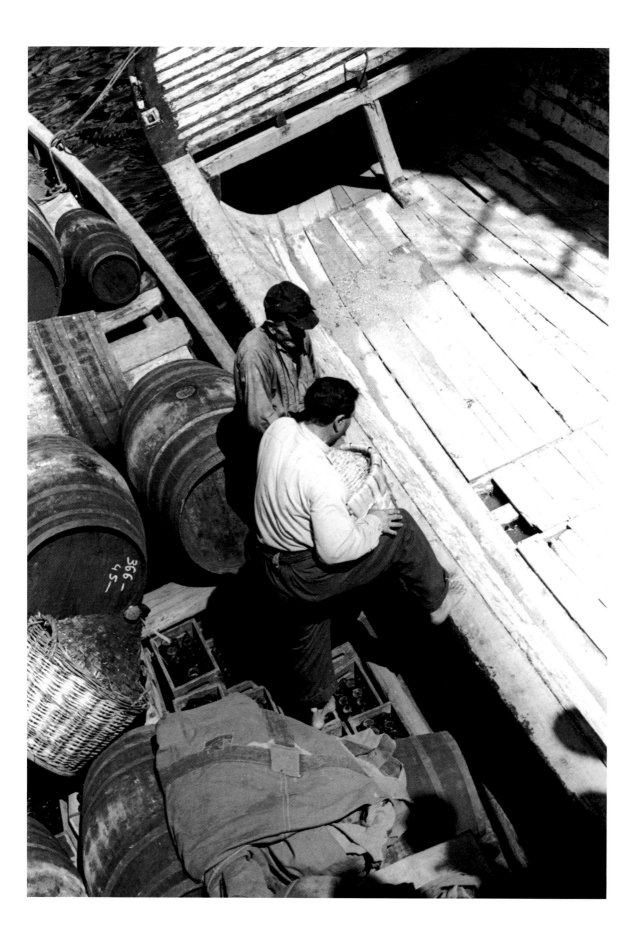

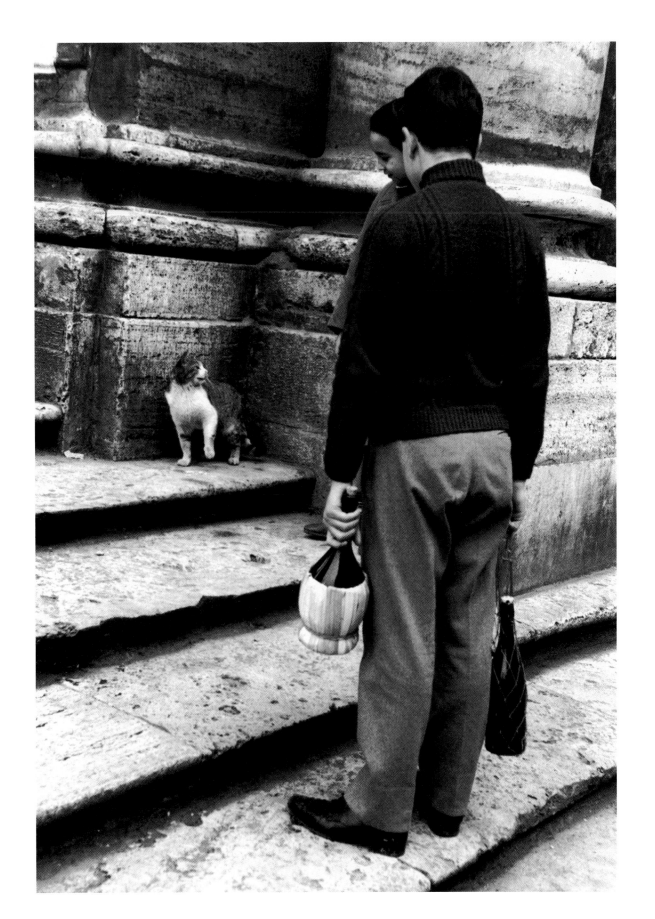

A hungry cat on the steps of the Pantheon in Rome would prefer a fish head to a kind word from a passing human.

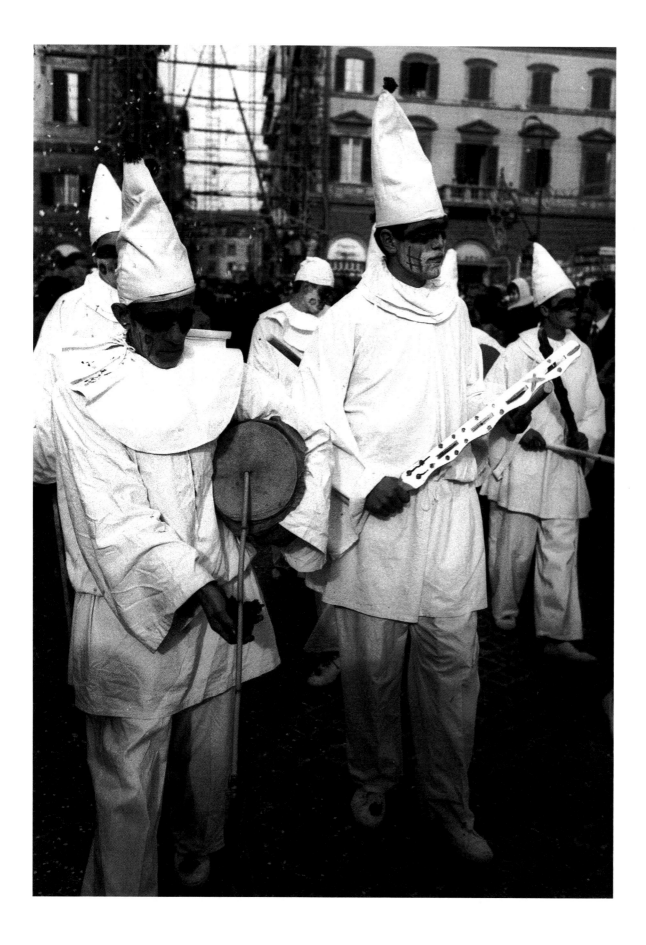

Left: Men costumed as eighteenth-century buffoons add color to the traditional carnival in Frascati. The carnival each February is also the time when the new Frascati wine is introduced. Cafés in the town will hang a tree branch over their doors to announce the new vintage.

Right: A singer on a street in Trastevere accompanies herself with a hand-cranked hurdy-gurdy. For the moment she interrupts her concert to gather up a few hundred *lire* from appreciative music lovers. Perhaps she will have enough to buy some food for her family.

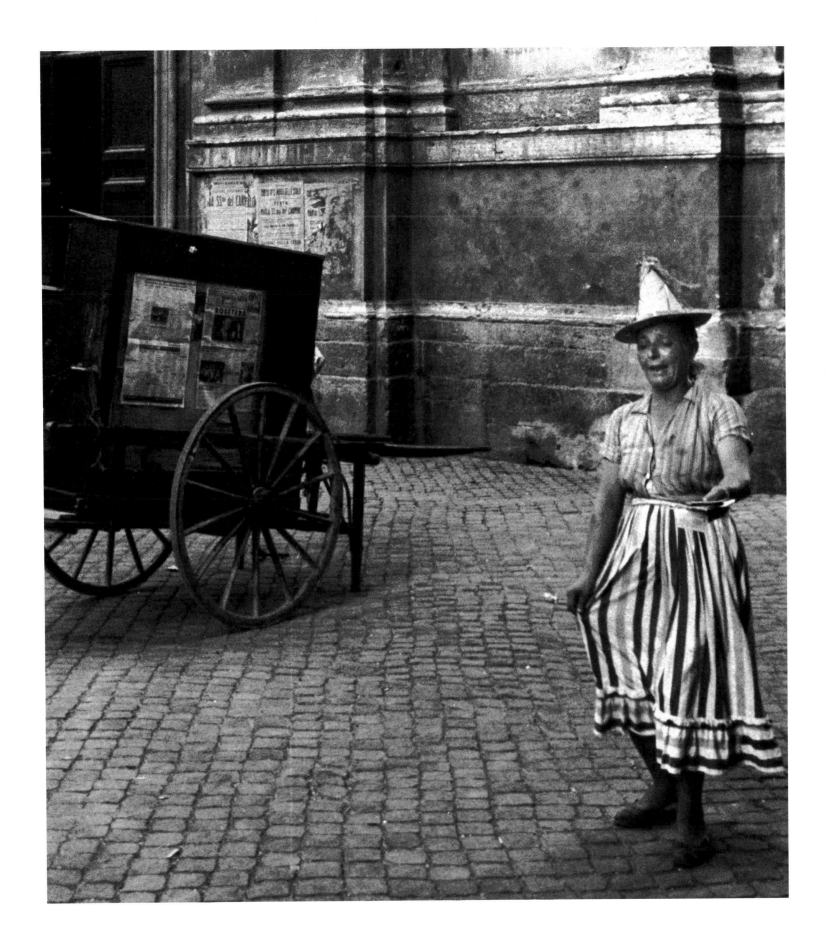

ITALY
'50s

Early morning in a back street of Naples, an accordionist rehearses for a job in a café where he will entertain the customers with his repertoire of Neapolitan street songs. At the moment, a child is his only audience.

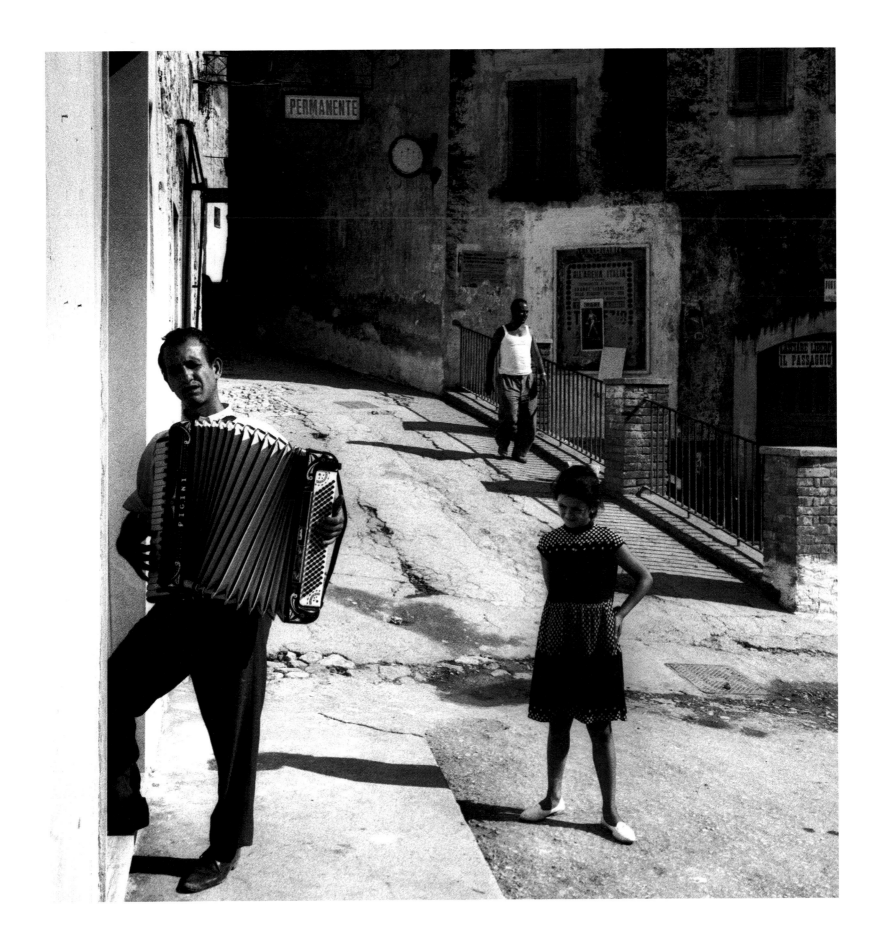

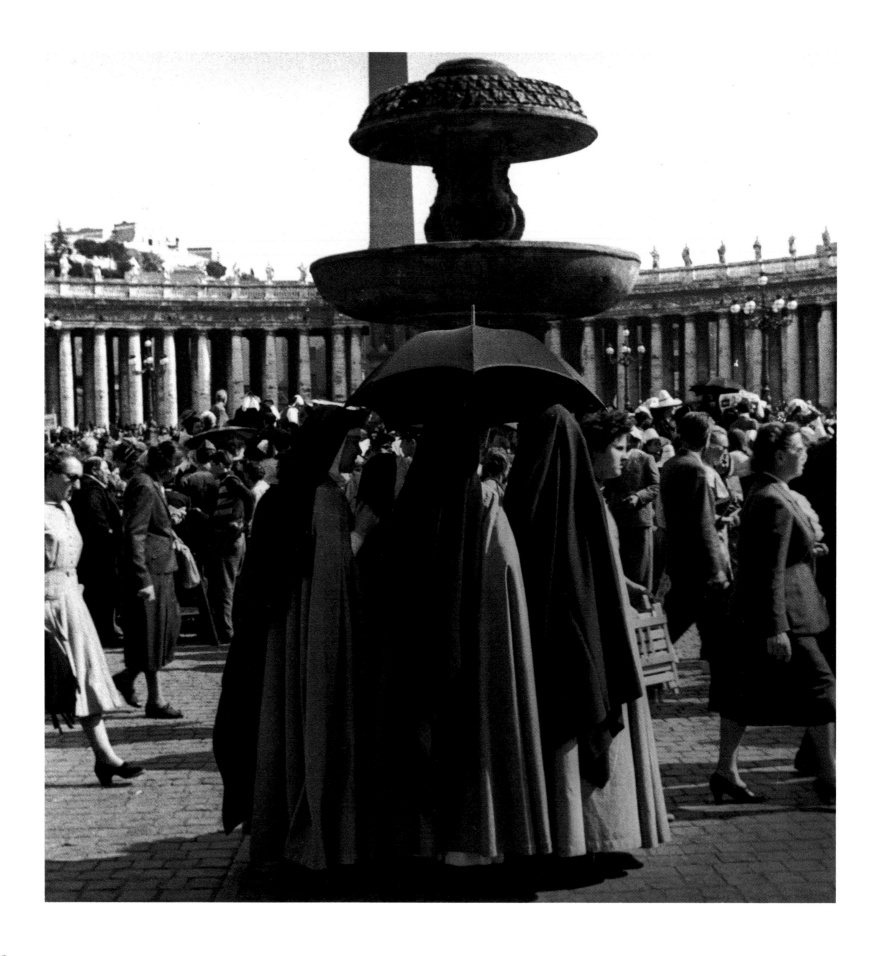

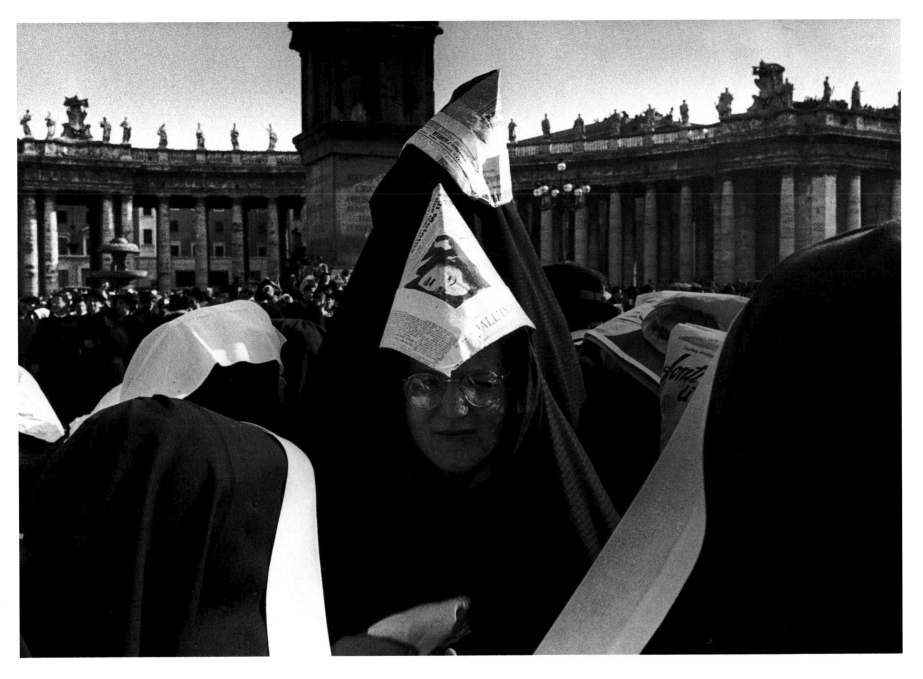

Nuns in St. Peter's Square, waiting for the Pope to
appear, invent original means of withstanding the
intense summer sun.

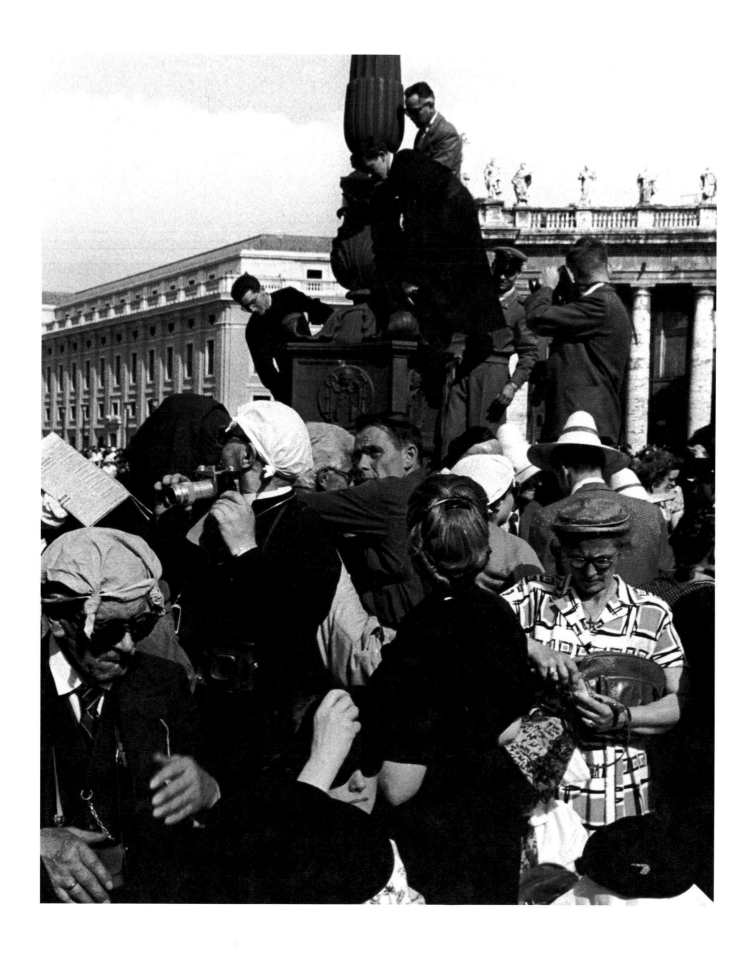

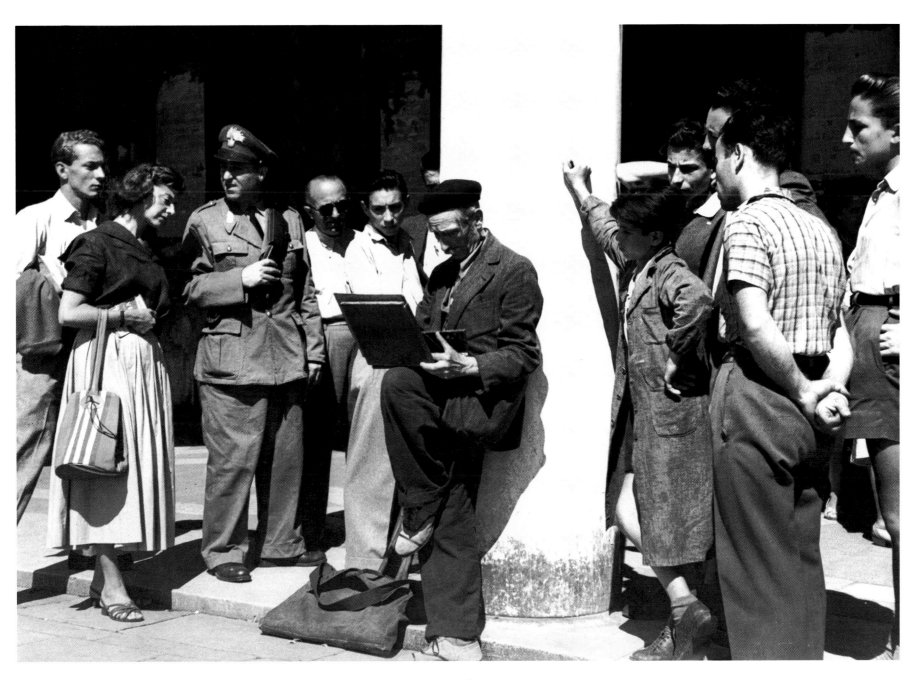

Above: A man sketching in the Piazza San Marco in
Venice attracts a group of interested bystanders.
Whether anyone will buy one of his works of art as a
souvenir is questionable.

Left: Waiting for the Pope to appear at his window in
St. Peter's Square is a major event for visitors to Rome.
They look for any vantage point from which to get even
a distant glimpse of the Holy Father.

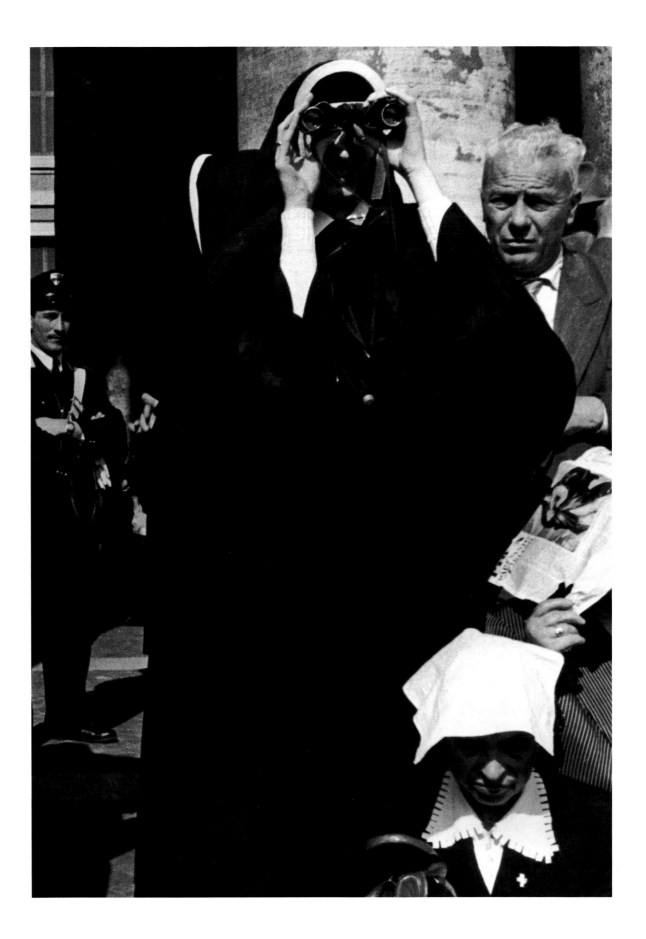

A nun focuses her high-powered binoculars on the window in the Vatican where the Pope is scheduled to appear. As she sees the Pontiff's lips moving in a blessing, it seems to be directed at her personally.

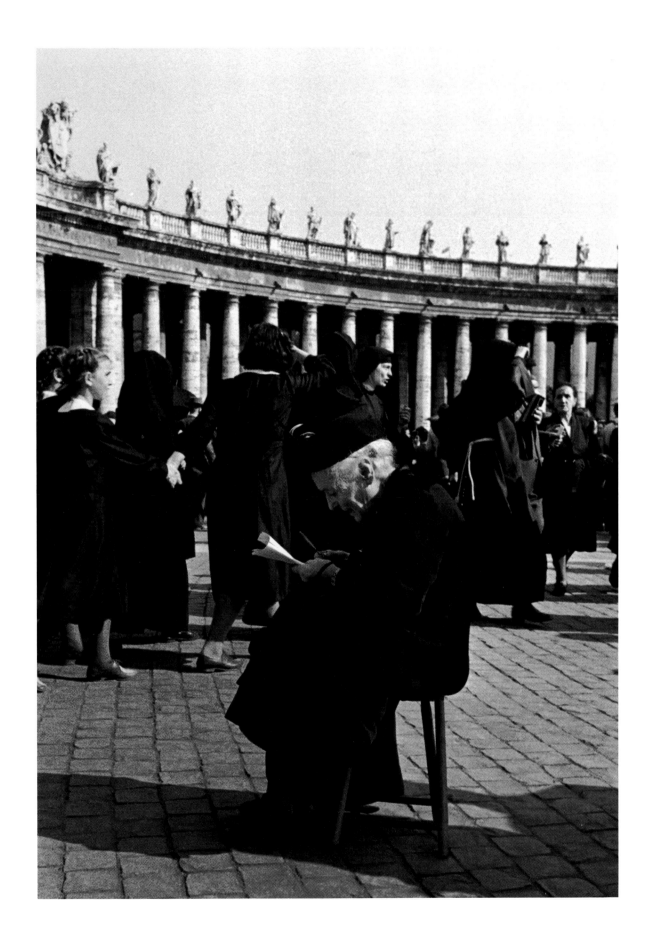

ITALY
'50s

An old woman in St. Peter's Square isolates herself from the crowds. Impervious to the excitement around her, she calmly reads a book.

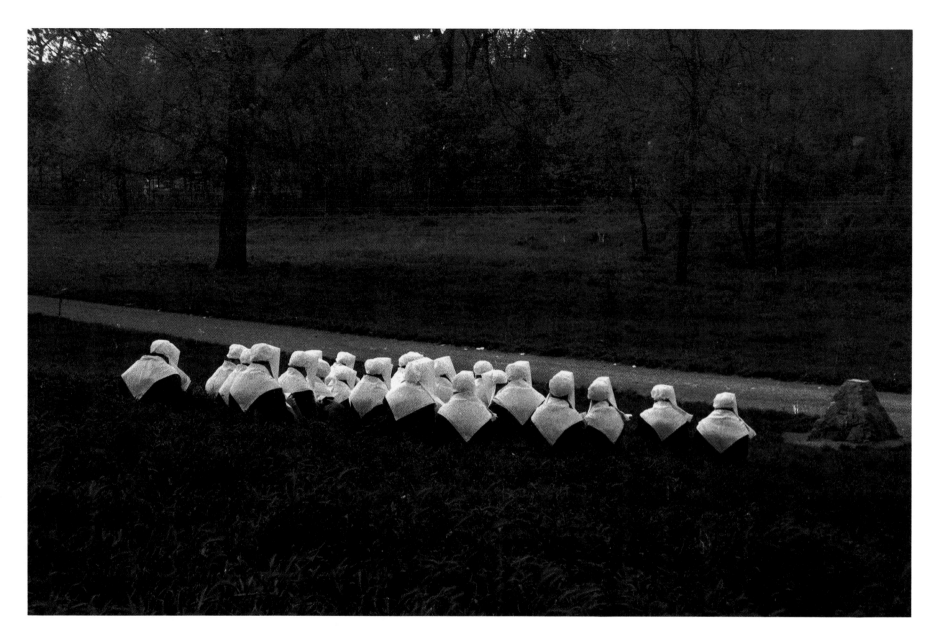

ITALY
'50s

Above: In a meadow near Verona, young novice nuns
dutifully bow their heads in prayer. The pattern of their
white fichus and coifs and the diminishing perspective
of their forms seem a perfect subject for a painter.

Right: The horses who pull the fiacres in Rome wait
patiently for their drivers and fares to return from visits
to museums and archaeological sites. In the summer they
wear straw bonnets. In winter they and their drivers bear
the rain and cold when there are few tourists to drive
through the city.

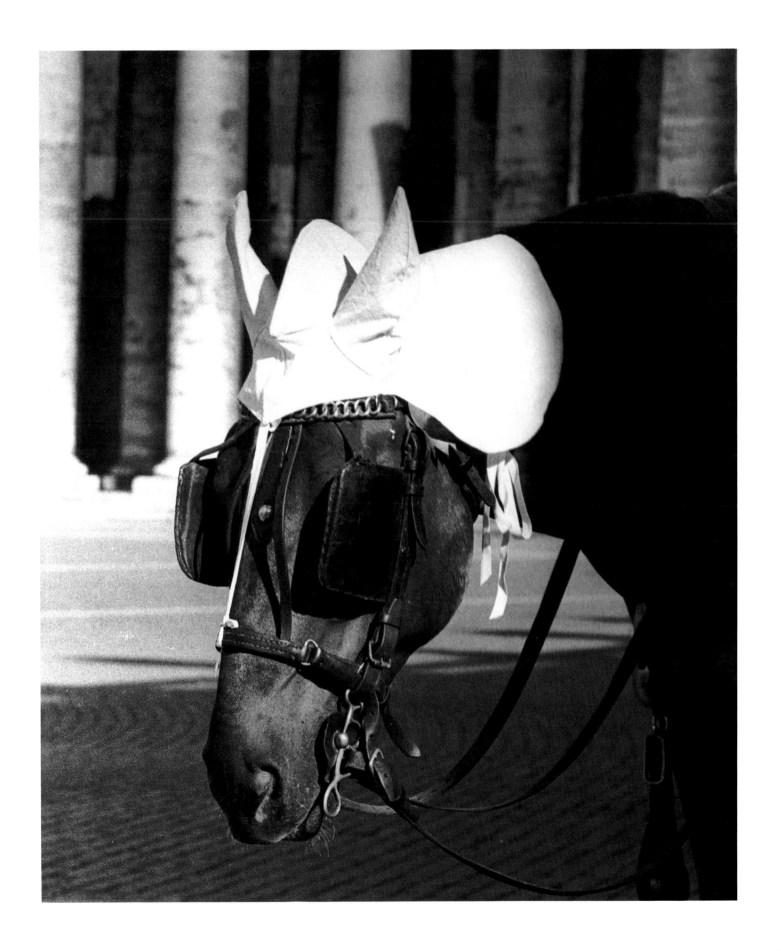

A few of the cats of Rome who have found an excellent refuge in the courtyard of 51 Via Margutta. Nino Franchina and Pericle Fazzini, sculptors whose studios are in the building, have fed generations of these Roman cats.

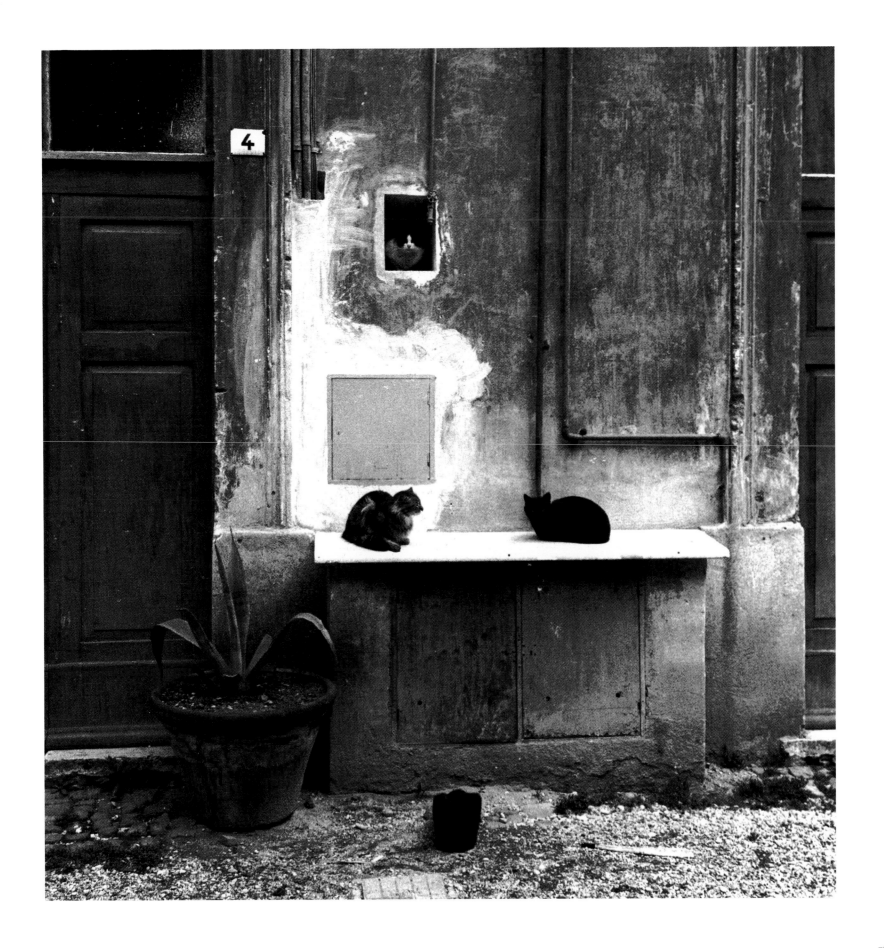

Louis, our Siamese cat, is not interested in the bronze wolf of Rome with Romulus and Remus behind him, as he looks for a lizard who has hidden in the marble acanthus leaves on the capital of a fallen Corinthian column. He likewise ignores the ruins of ancient Rome, preferring to follow the flight of a pigeon. In the Colosseum, Louis seems to resemble one of the wild beasts who were brought in to devour Christians.

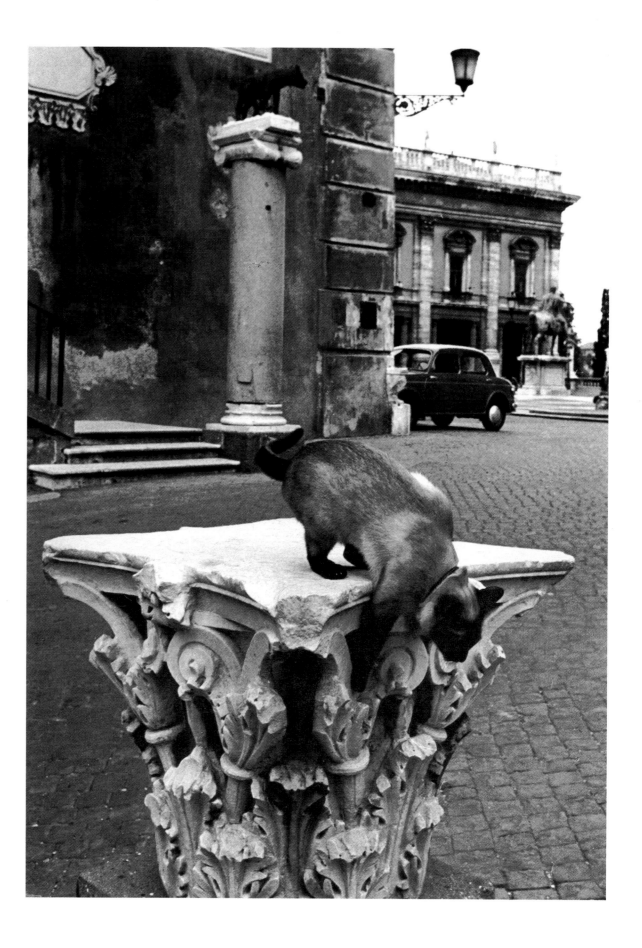

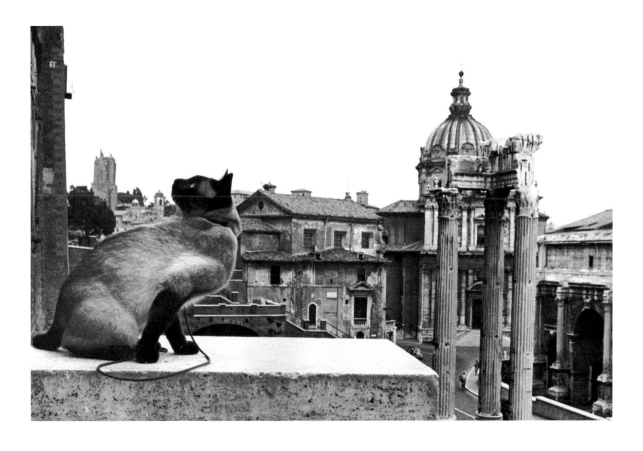

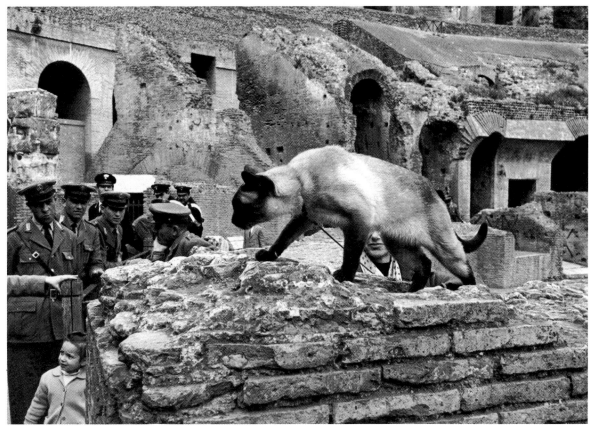

ITALY
'50s

A Swiss Guard at an entrance to St. Peter's in Rome is costumed in a medieval uniform in the official Vatican colors of blue and yellow and the insignia of the Vatican coat of arms. Traditionally the Vatican guards are mercenaries from Switzerland.

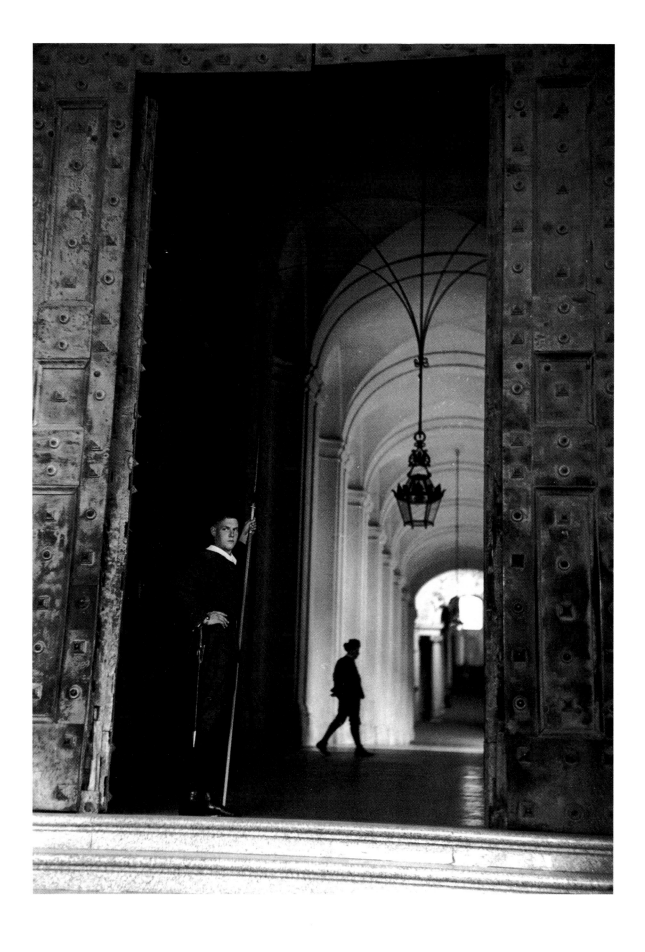

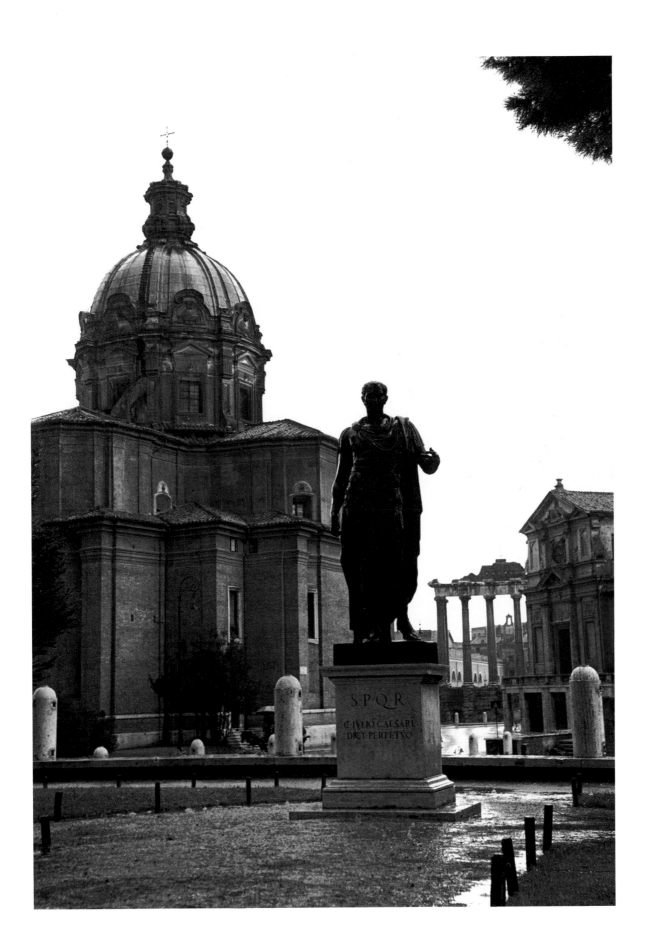

The bronze statue of Julius Caesar stands on a pedestal overlooking Rome. Behind him are the ruins of the city he knew. The initials SPQR stand for *senatus populusque Romanus* (the senate and the people of Rome).

A doorway in the ruins of a
Roman villa in Pompeii might
have led to a room where there
was laughter, conversation,
and music until the ash from
the Vesuvius eruption in 79
A.D. stilled the sound forever.

Some benches in a secluded corner of the Borghese Gardens on a rainy winter day. Forsaken now, they will be used by nursemaids, lovers, and lonely old women when spring comes and the welcome sun dries their wooden slats.

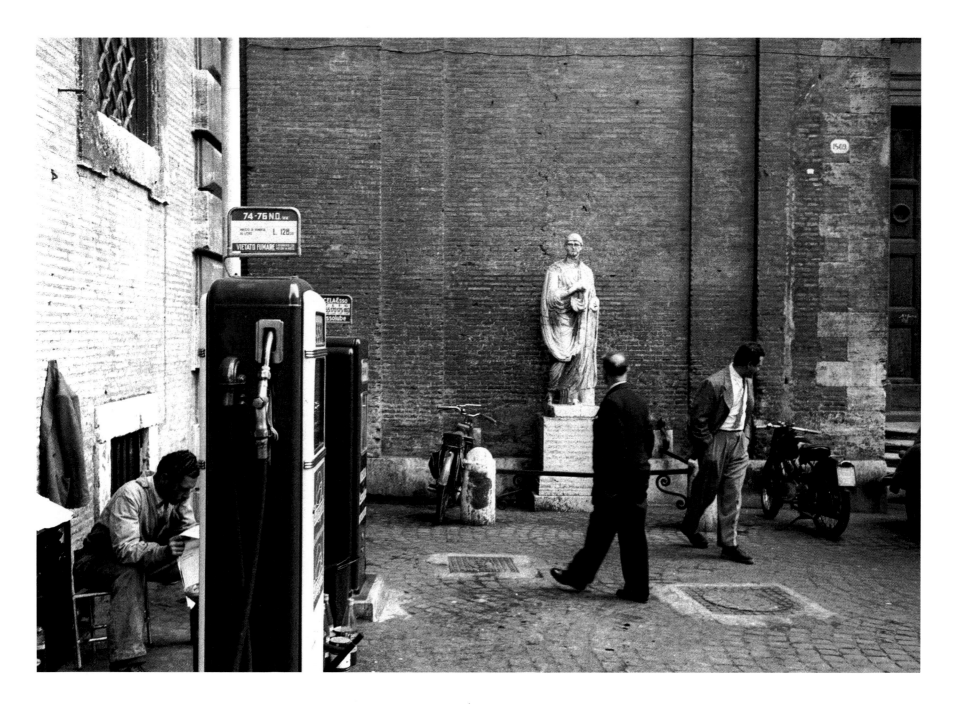

The ancient and the modern are often juxtaposed in Italy—*above,* at a street corner in Rome and, *right,* in a gas station in Ostia. This conjunction of Roman antiquities and modern motor oils exemplifies the two civilizations of Ostia. Once a thriving Roman port, it is now a popular seaside resort.

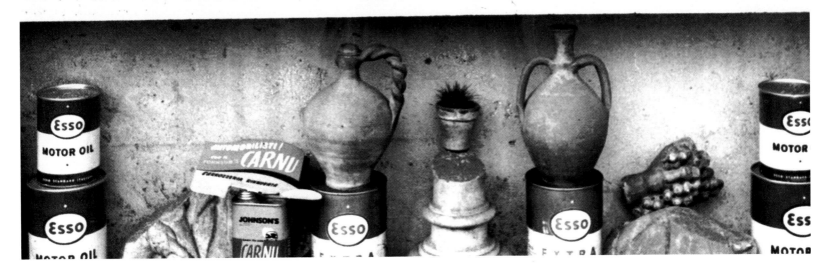

American students who come
to Rome to take advantage
of specialized studies in lan-
guage, archaeology, and art
are befriended by Roman
young people who share their
interests.

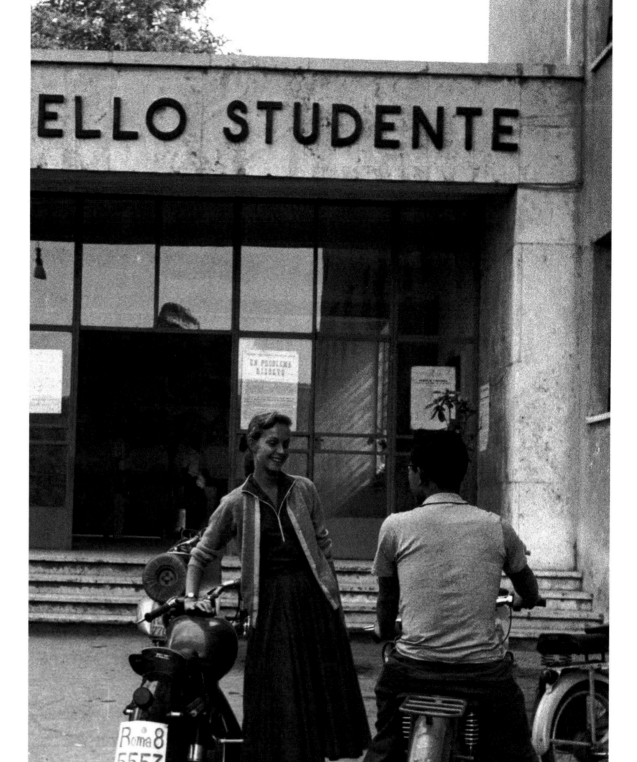

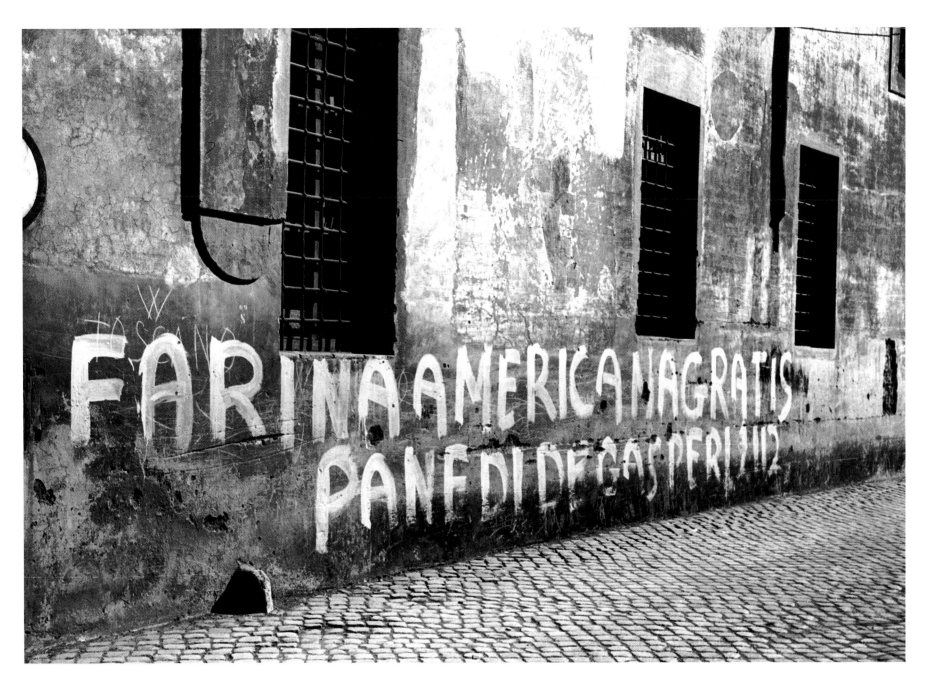

On a wall outside of Rome, graffiti reflect the anger of Italians when the free flour offered to Italy by the Marshall Plan after World War II was used for bread that was sold at 112 lire a kilo. The people of Italy blamed the prime minister, Alcide de Gasperi, for misusing the flour, which was intended to feed the needy in postwar distressed areas. The sign says "American flour is free but De Gasperi's bread is 112 lire."

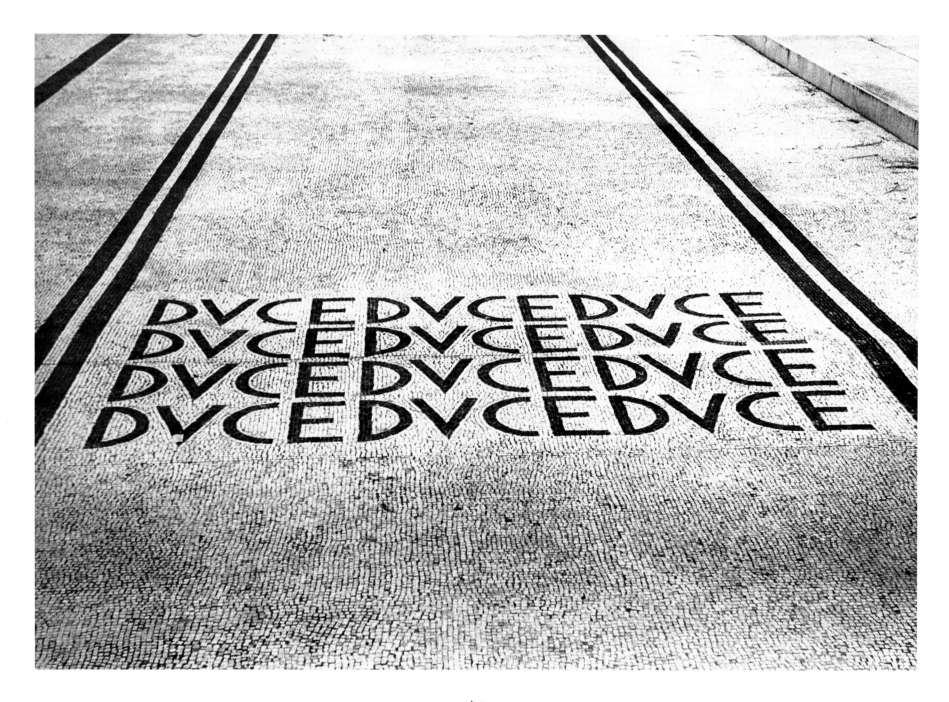

A tiled walkway in Rome still bears the word *Duce,*
a symbol of Mussolini's self-aggrandizement.

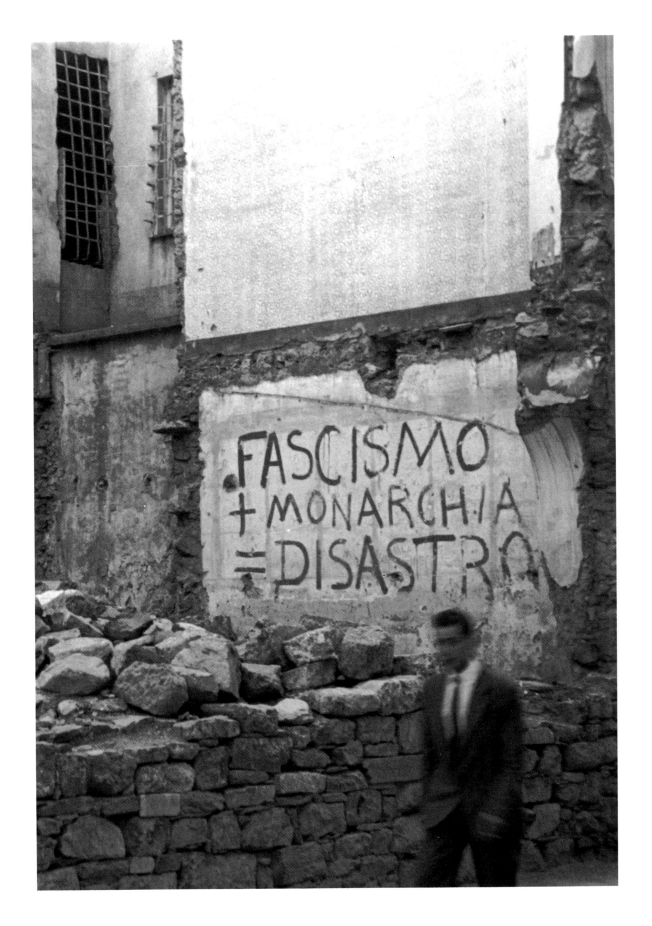

Prophetic words are painted on a wall in the town of La Spézia —a moral protest, valid even now.

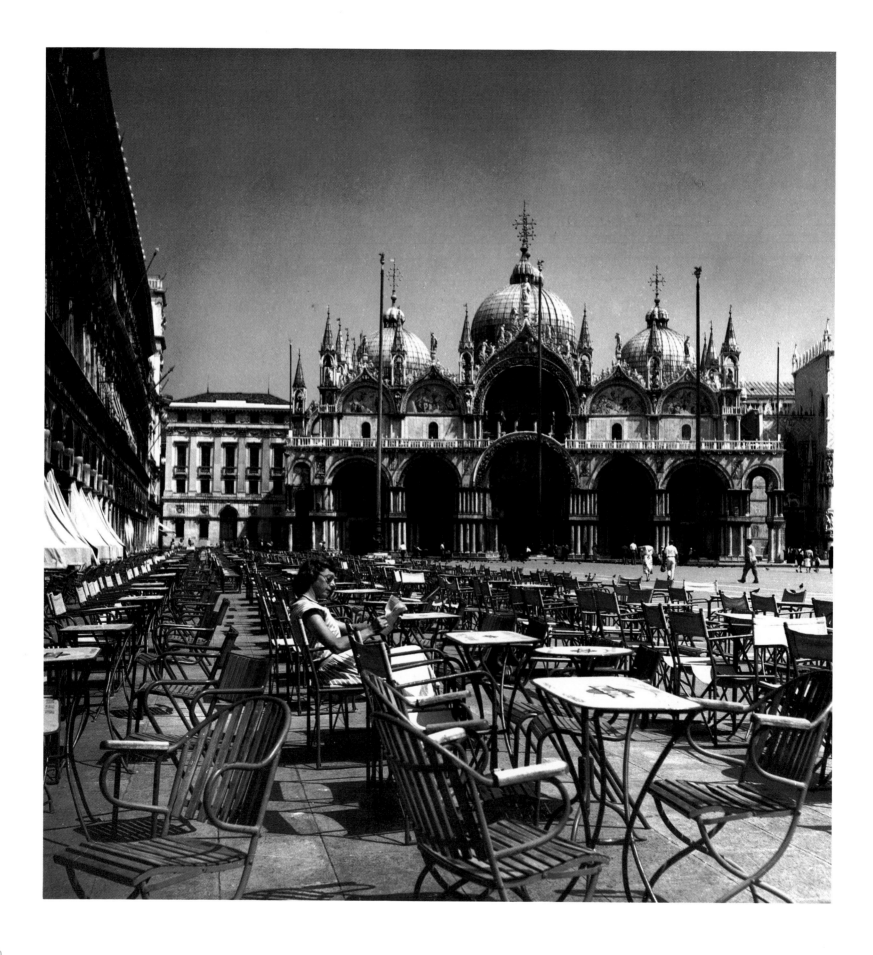

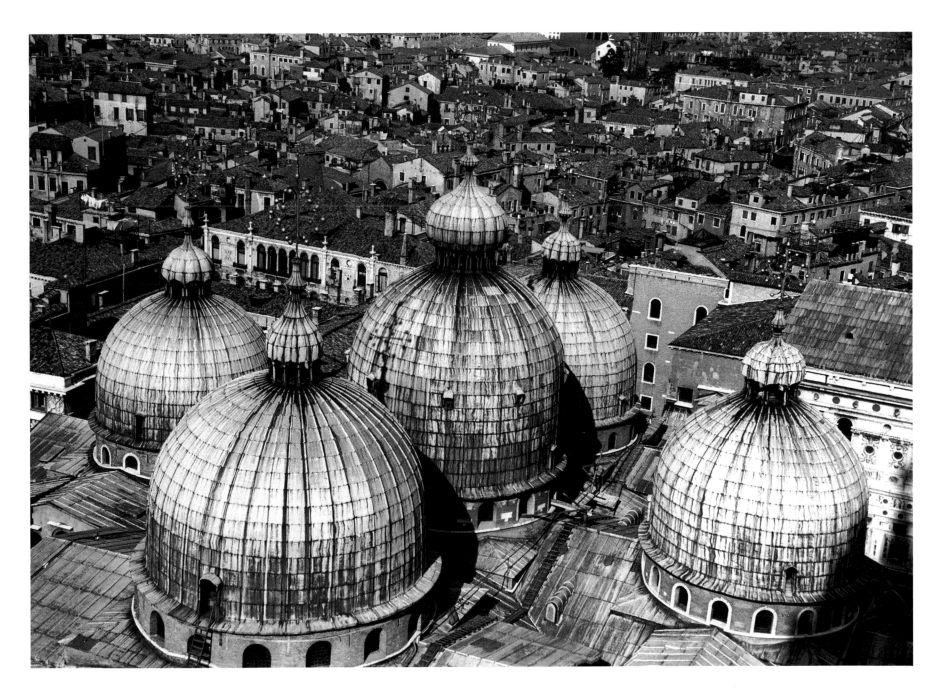

Left: It is high noon in Venice as the sun envelopes Florian's. Most coffee drinkers prefer the café opposite, which is in the shade, but a lone woman surrounded by empty tables and chairs is impervious to the solar rays.

Above: Seen from the top of the Campanile, the domes of the Basilica di San Marco reveal their magnificence and architectural symmetry.

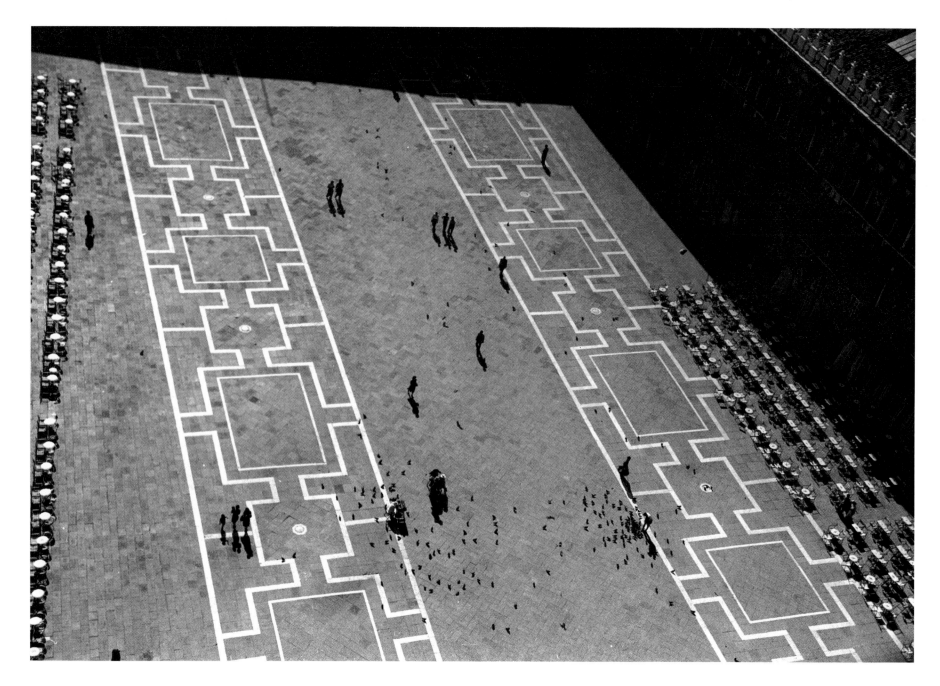

The Campanile in Piazza San Marco collapsed in 1902 but was reconstructed in its original position, offering the best view of Venice if one has the stamina to climb to the top of the tower.

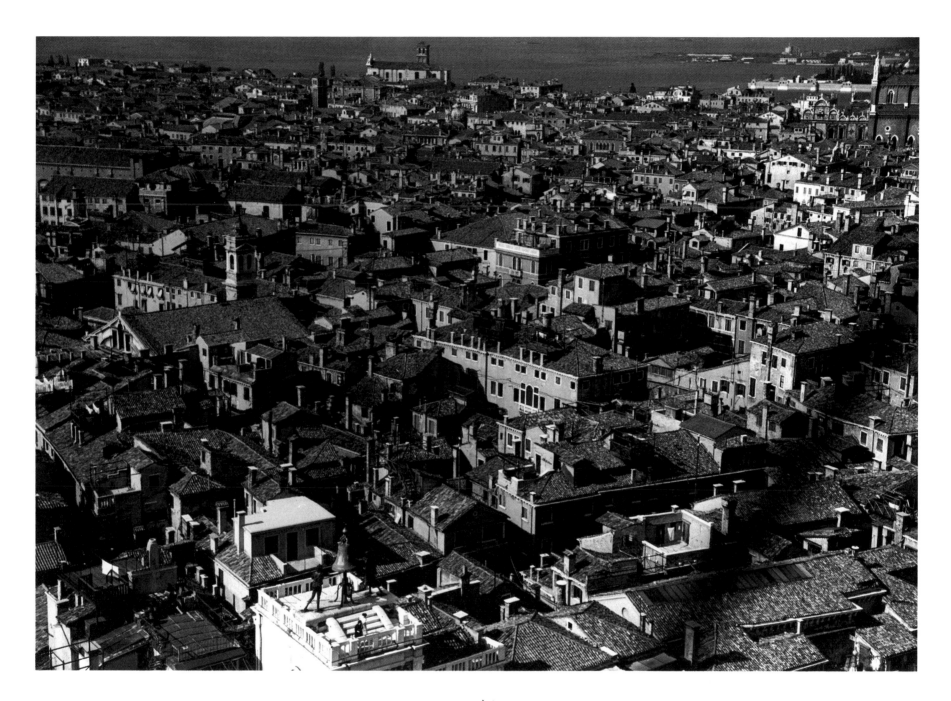

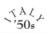
The view from the top of the Campanile reveals all of Venice's landmarks, a sight a seagull witnesses daily on his search for fish in the market.

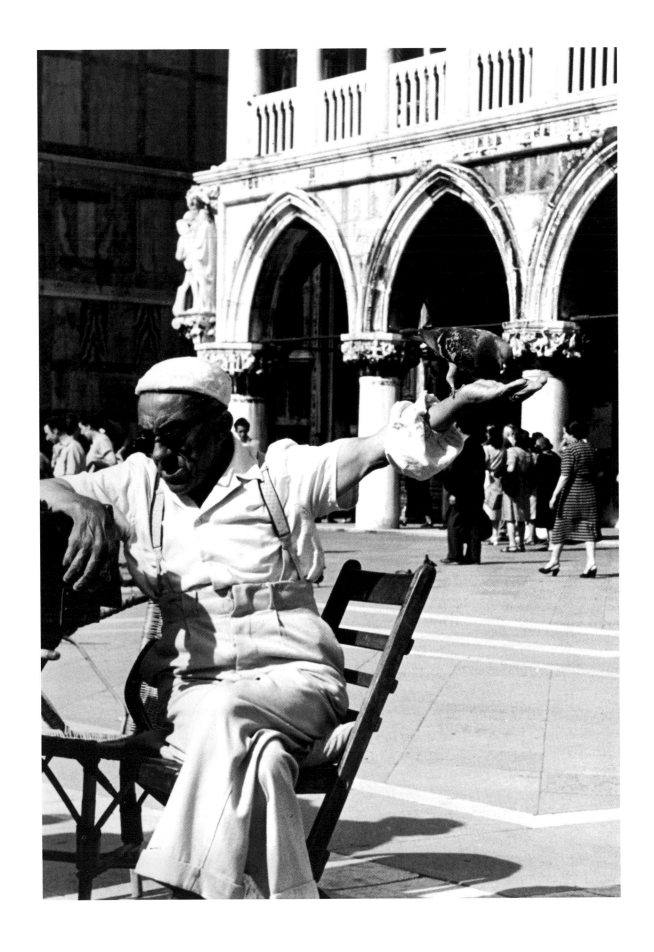

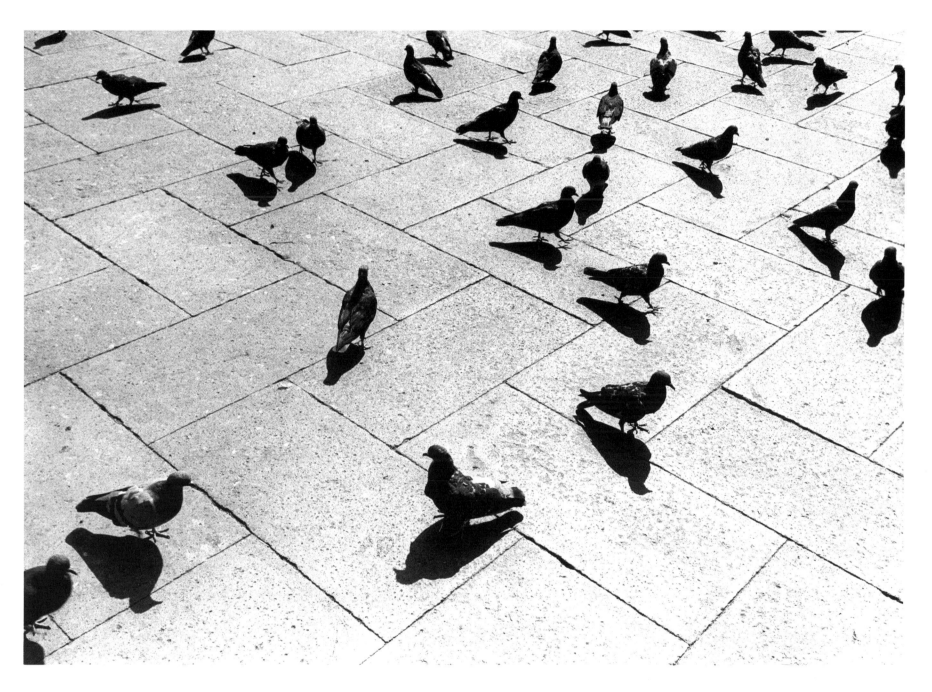

ITALY
'50s

Above: In Piazza San Marco in Venice, pigeons and their shadows form a pattern so decorative it might be used as a tapestry or an example of chiaroscuro design.

Left: A vendor of dried corn, which tourists buy to feed the pigeons in the piazza. A pigeon nibbling the corn from his hand serves as an advertisement for the quality of the product.

A gondola passes the balustrade of a garden belonging
to the house where Richard Wagner lived during the
times he spent in Venice.

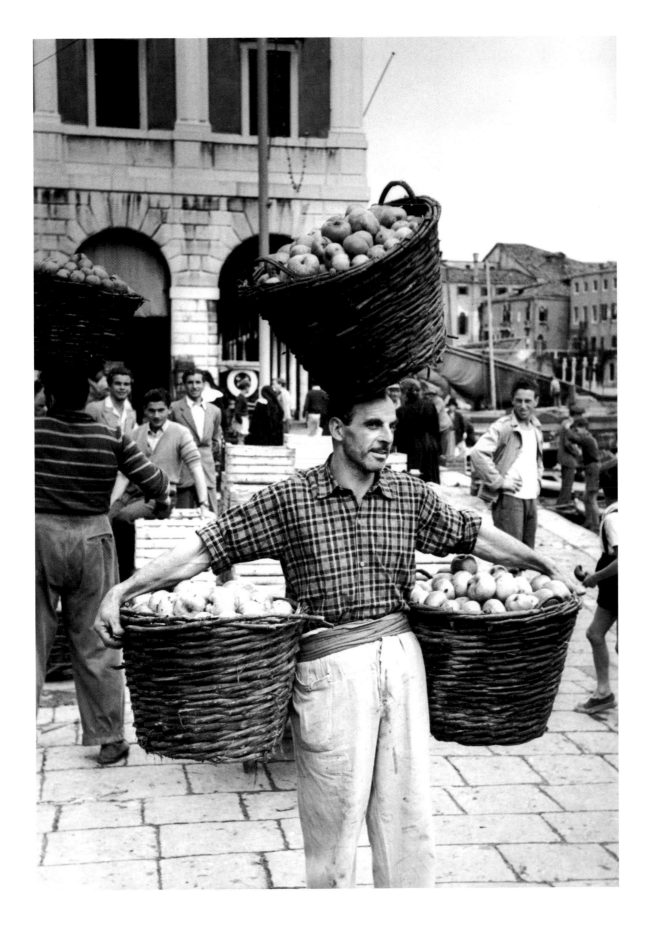

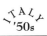
The men who deliver produce to Venice are probably the inheritors of their profession from sixteenth-century ancestors.

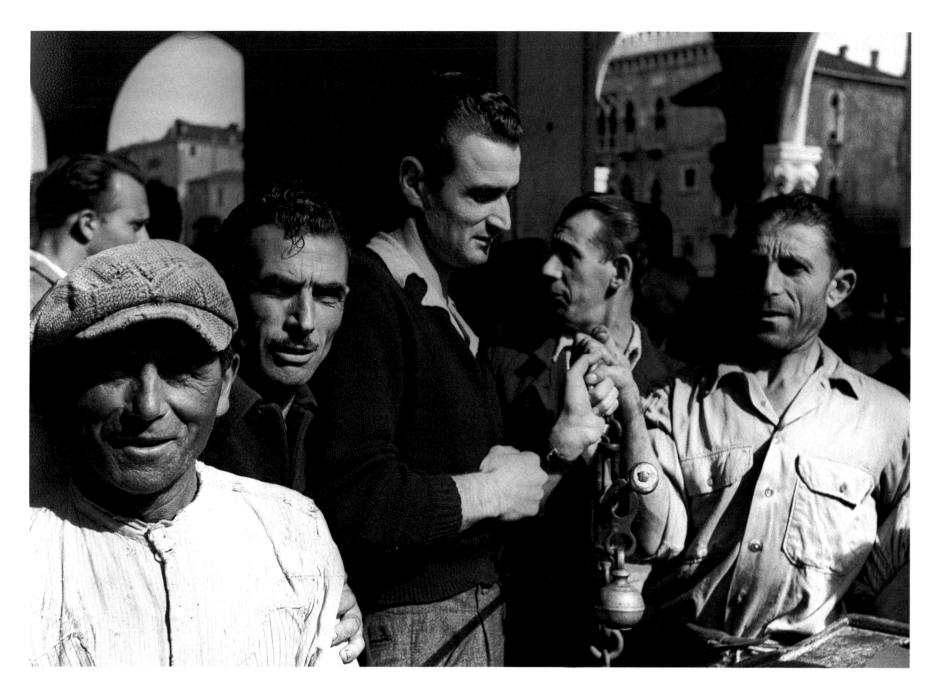

ITALY
'50s

Faces in the market in Venice have the striking contours
of heads in sixteenth-century portraits by Titian and
Piazzetta. The models the master painters used may
have been forebears of these contemporary men.

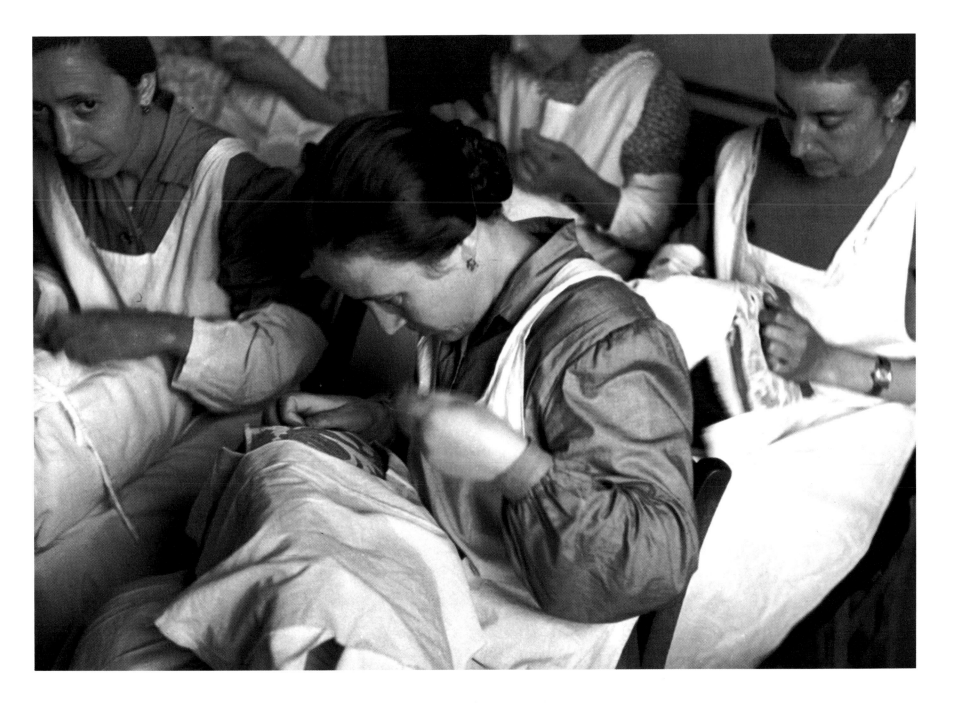

The lace makers on the island of Burano join generations of skillful women who create the delicate traditional Pointe de Venise lace. It will be used on bridal gowns, christening robes, royal trousseau linens, or perhaps a simple collar on a child's dress.

Alberto Moravia, the world-renowned novelist, on the roof of his home near Piazza del Popolo in Rome.

Novelist Elsa Morandi has gained an international reputation for her work.

MOVIES

Italian actress Rossana Podestà is seated at the Caffè Greco on Via Condotti in Rome. Oscar Wilde and Mark Twain may have had their coffee at the same table in this renowned café, unchanged in decor or service for a century.

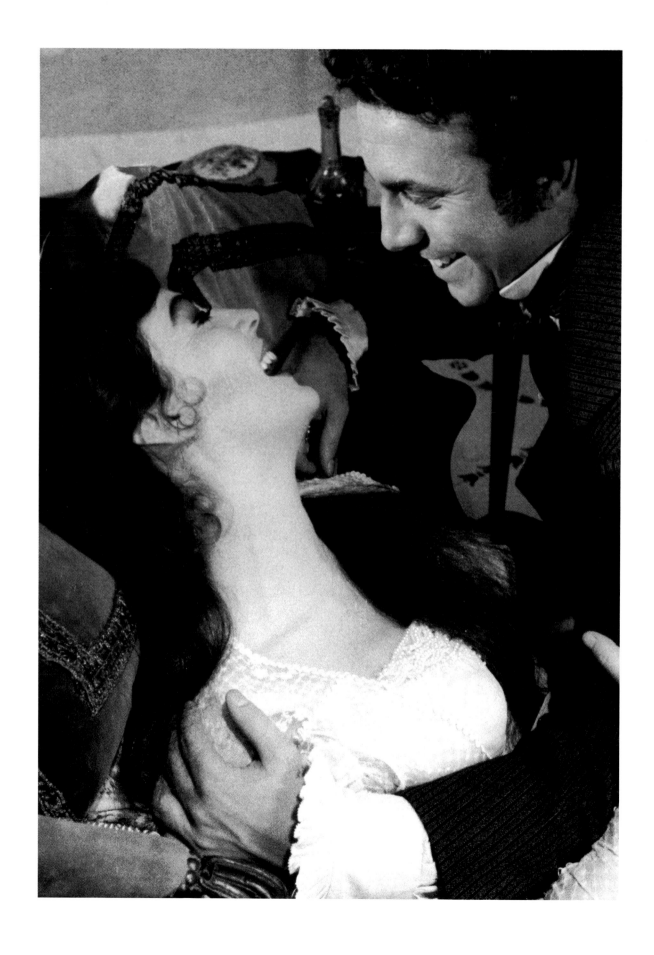

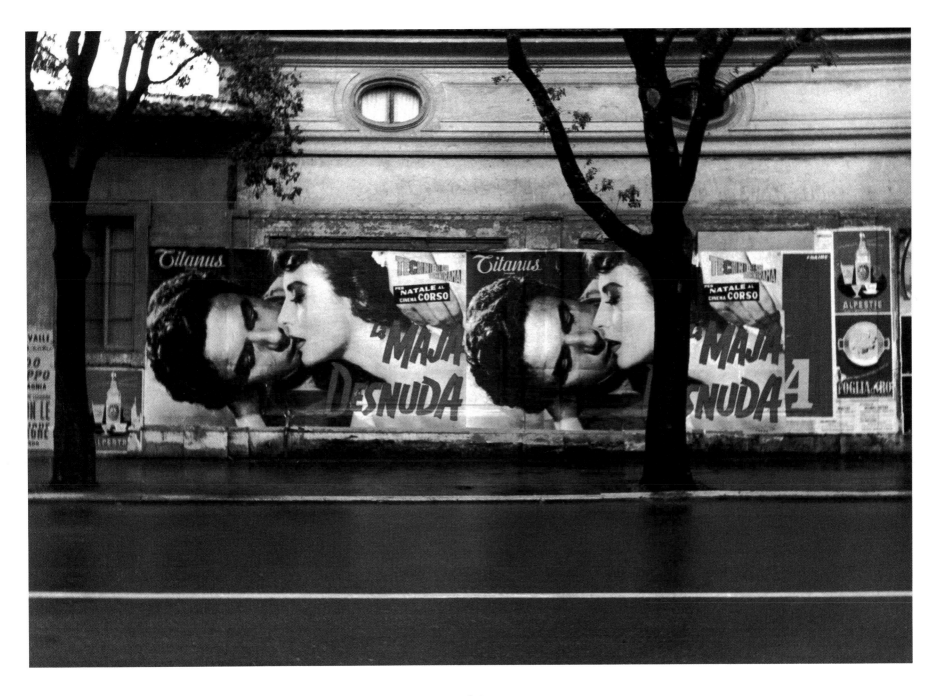

Ava Gardner and Tony Franciosa rehearsing a love scene
from the film *Naked Maja,* in which she played the
Duchess of Alba and he Goya. Publicity posters for the
film, which were accidentally printed horizontally, adorn
a street in Rome.

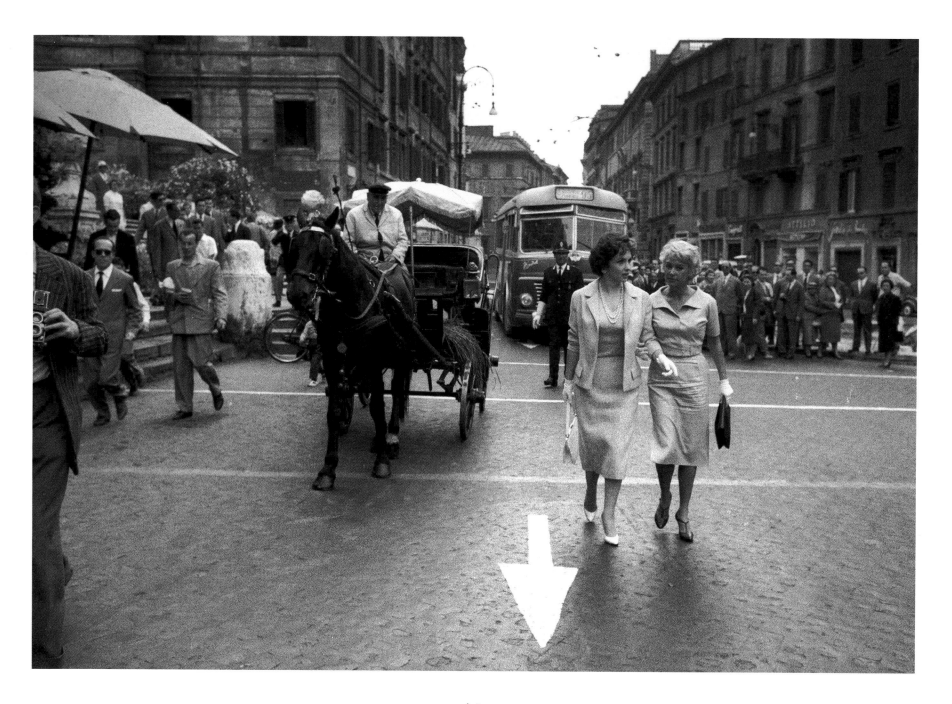

ITALY
'50s

Two friends, Gina Lollobrigida and Martine Carol, stop traffic on Piazza di Spagna on their way to the exclusive shopping street, Via Condotti.

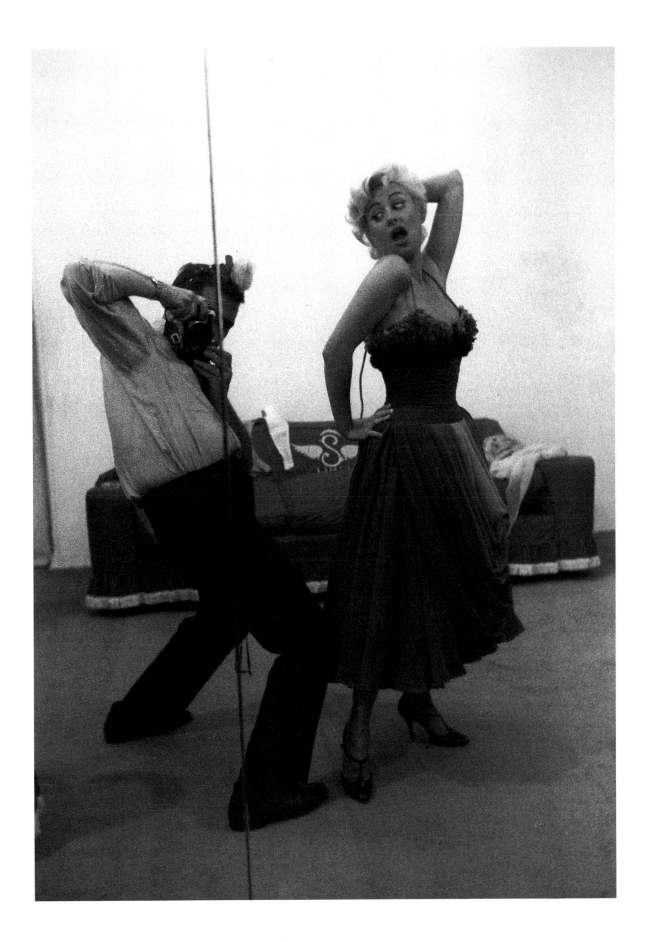

Sanford Roth is reflected in a
mirror at Schuberth's as he
photographs Martine Carol.
Schuberth, a well-known
couturier in Rome in the
fifties, designed clothes for
most of the film stars.

Ava Gardner, on location for
Naked Maja, rests between
scenes, reading the Rome
Daily American, an English-
language newspaper. All
current news items were
contained in this tabloid-size
periodical.

Aldous Huxley, like all visitors to Rome, stops at Tre Scalini, in Piazza Navona, to taste the famous *gelato* specialty, *tartufo*. While in Rome, Huxley visited the set of the film *Helen of Troy* at Cinecittà and gave his approval on the studio replica of the Trojan horse.

Italian cinema star Monica
Vitti, French star Alain
Delon, and Italian director
Michelangelo Antonioni on
location for a film.

ITALY
'50s

Romy Schneider and Alain
Delon, two of the world's most
beautiful people, as they were
in the fifties in Rome.

 ITALY '50s

Luchino Visconti, a director of films who has gained international recognition.

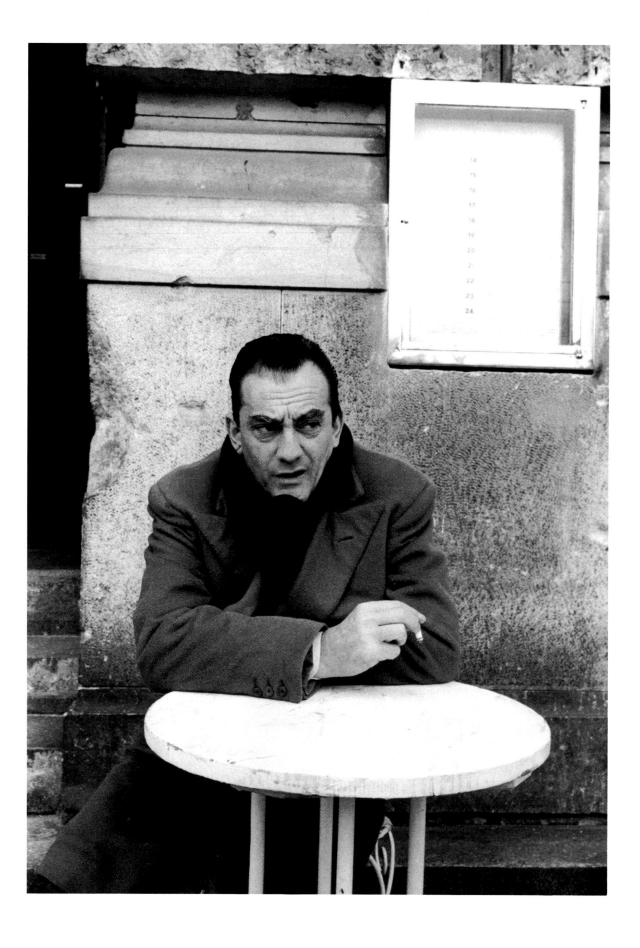

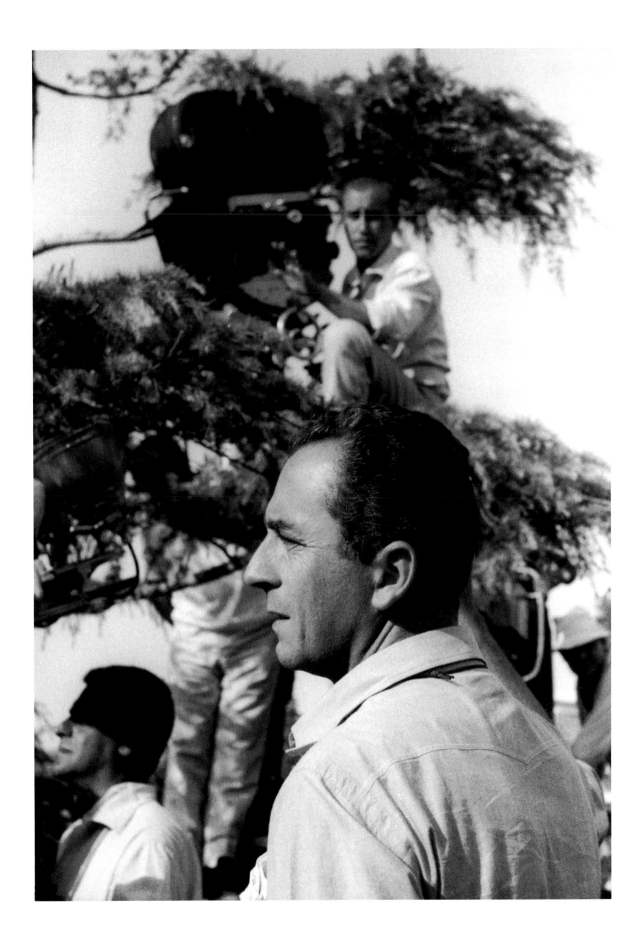

Director Michelangelo Anton-
ioni watches a scene with a
critical eye.

ARTISTS

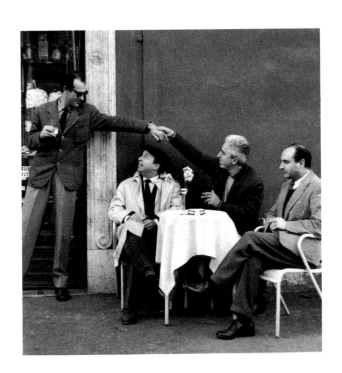

Giorgio de Chirico, perhaps the best known of modern Italian painters, was a founder of the Metaphysical School, but later reacted against modernism and founded the Novecento, which espoused traditional, classical art.

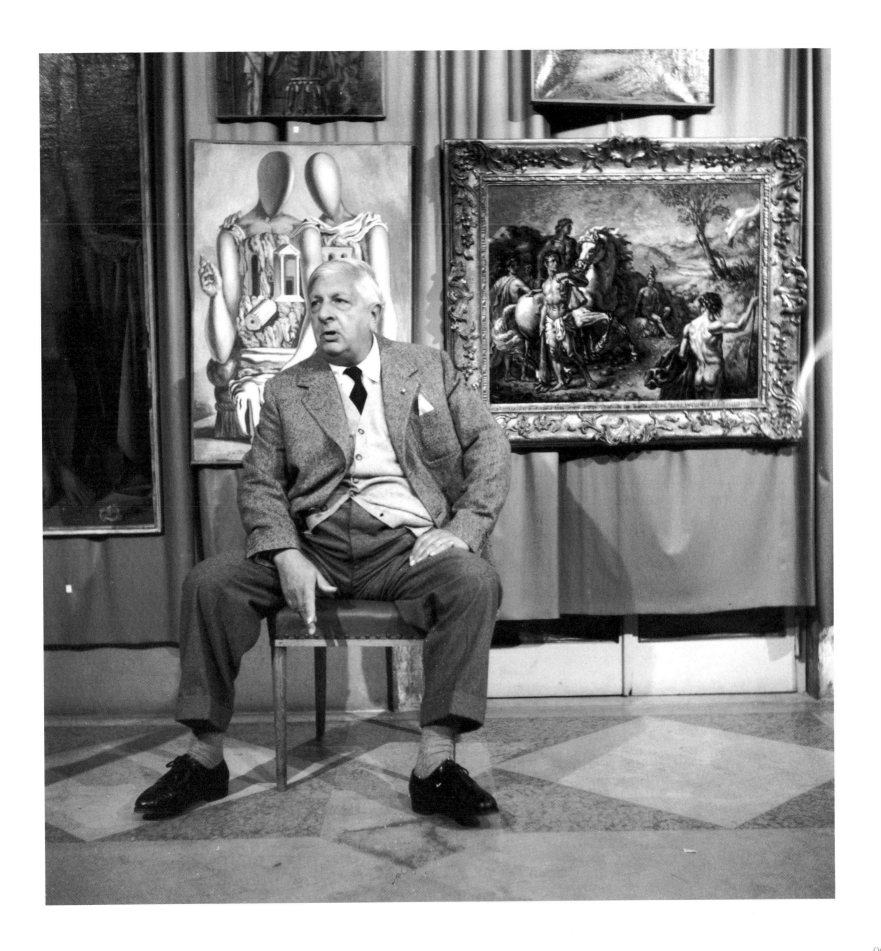

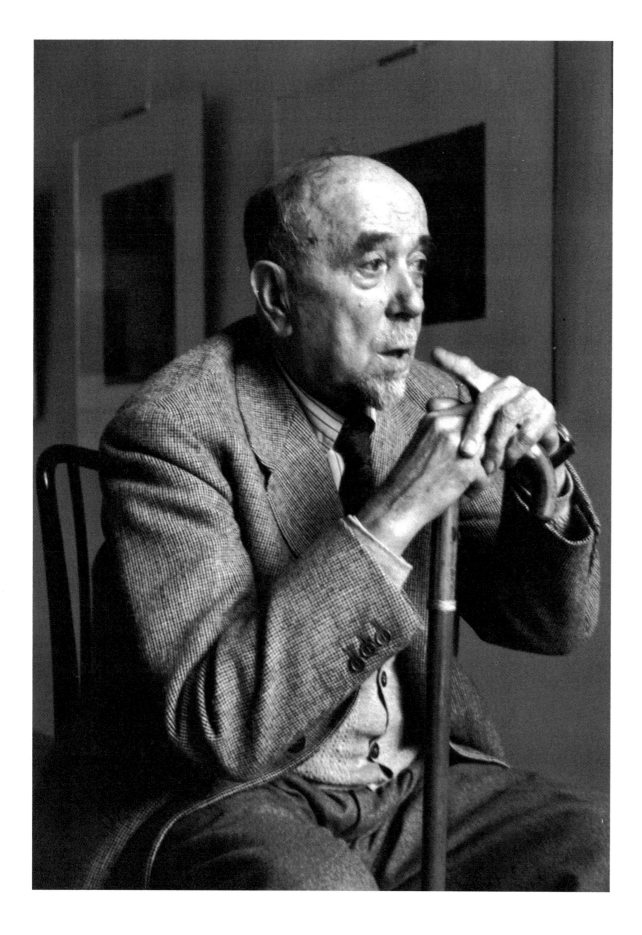

Arturo Tosi was one of the founders of the Novecento Italiano in 1922, returning to classical painting as a reaction against the modern movements in France and Italy.

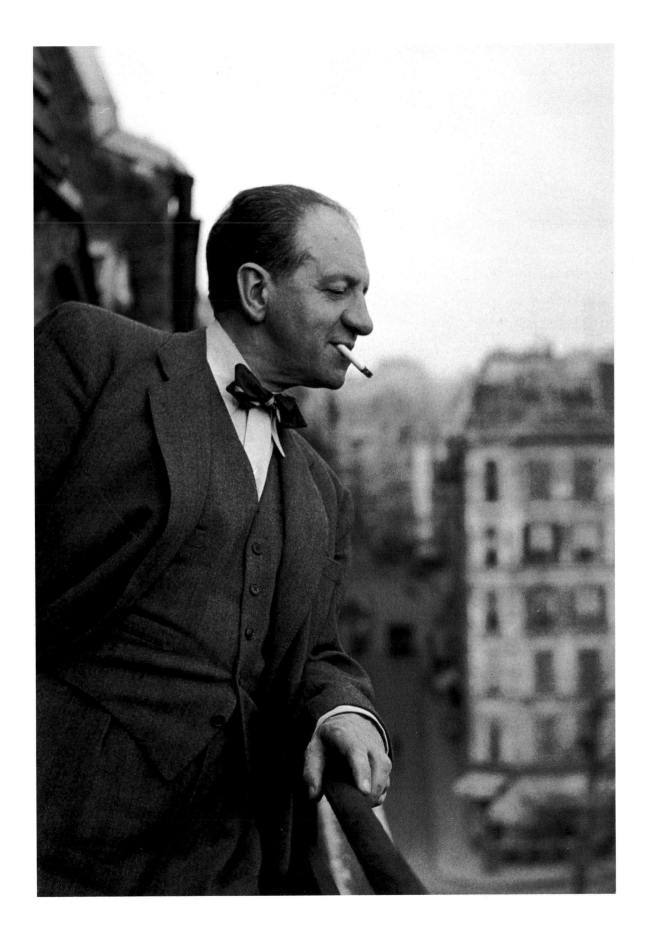

Milanese artist Renato Birolli
fought the neoclassical
Novecento group and pro–
duced colorful, nonfigurative,
expressionistic works.

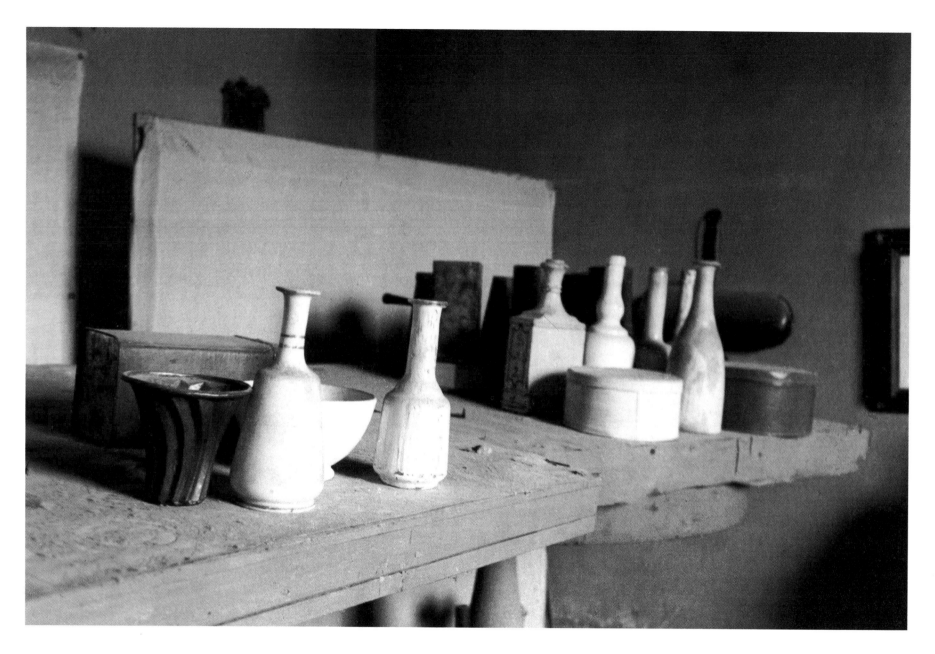

Giorgio Morandi was famous for painting the same white bottles, bowls, and jars again and again in varied still lifes, a few of which can be seen here. His subjects make interesting fare for a photographer also.

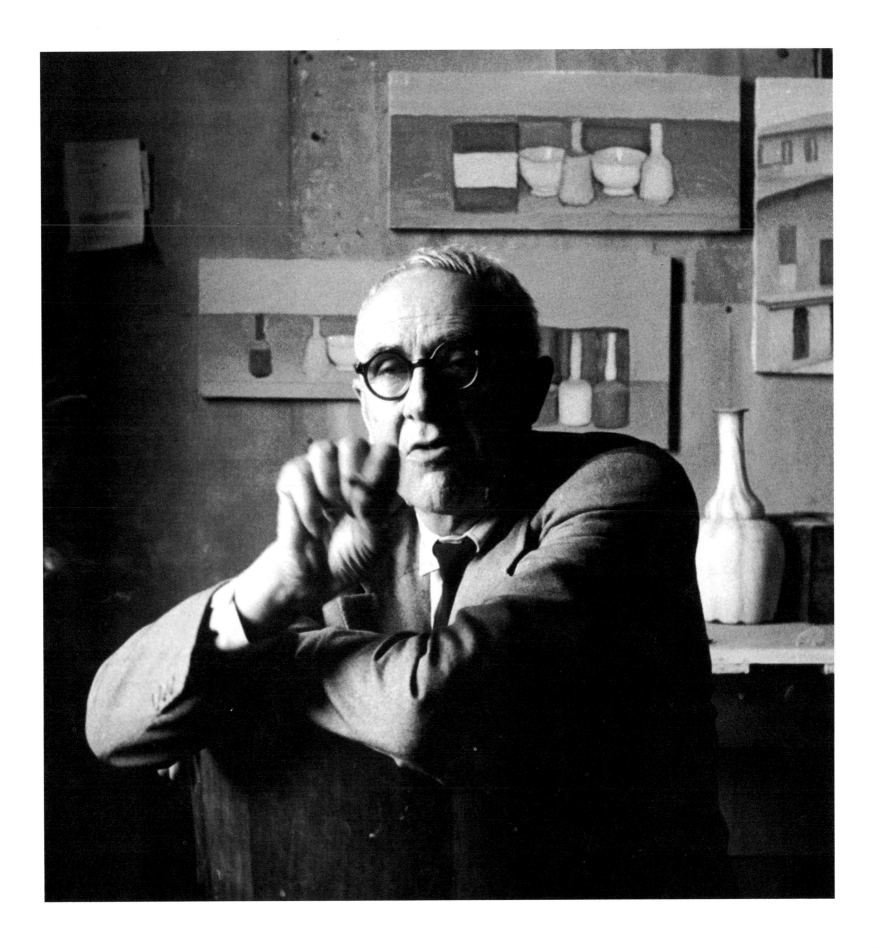

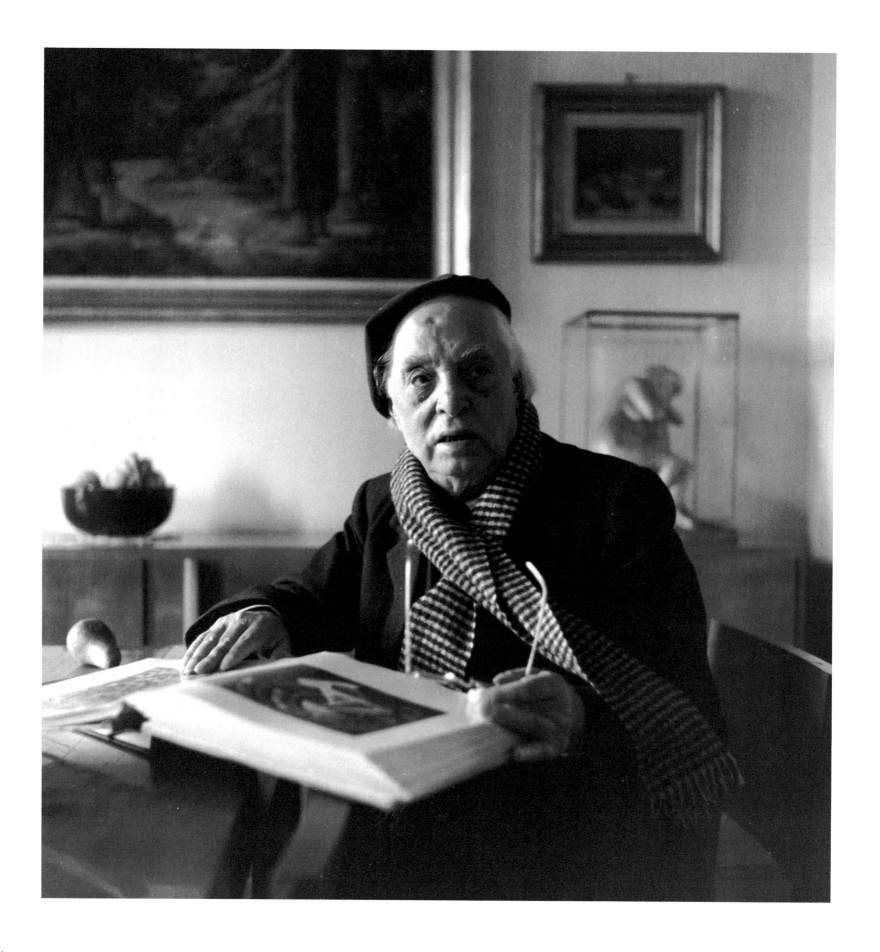

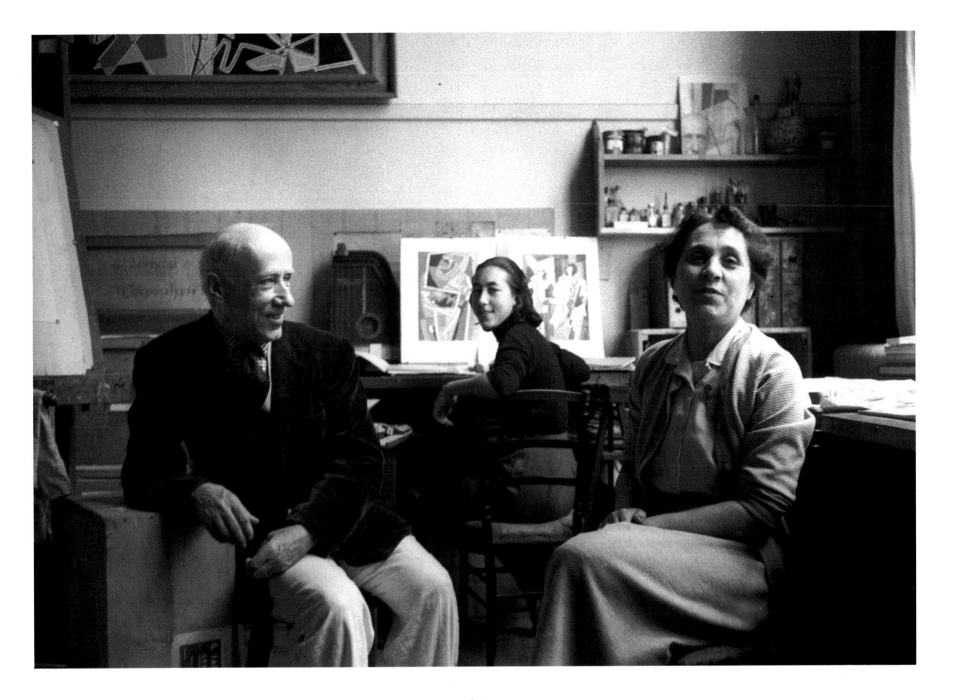

Left: Carlo Carrà was one of the Futurists, then part of the Metaphysical group, and later joined the Novecento Italiano.

Above: Gino Severini, one of the founders of the Futurist movement, with his wife and daughter in Rome.

Giuseppe Santomaso began as a figurative artist but his work became more abstract in the postwar years.

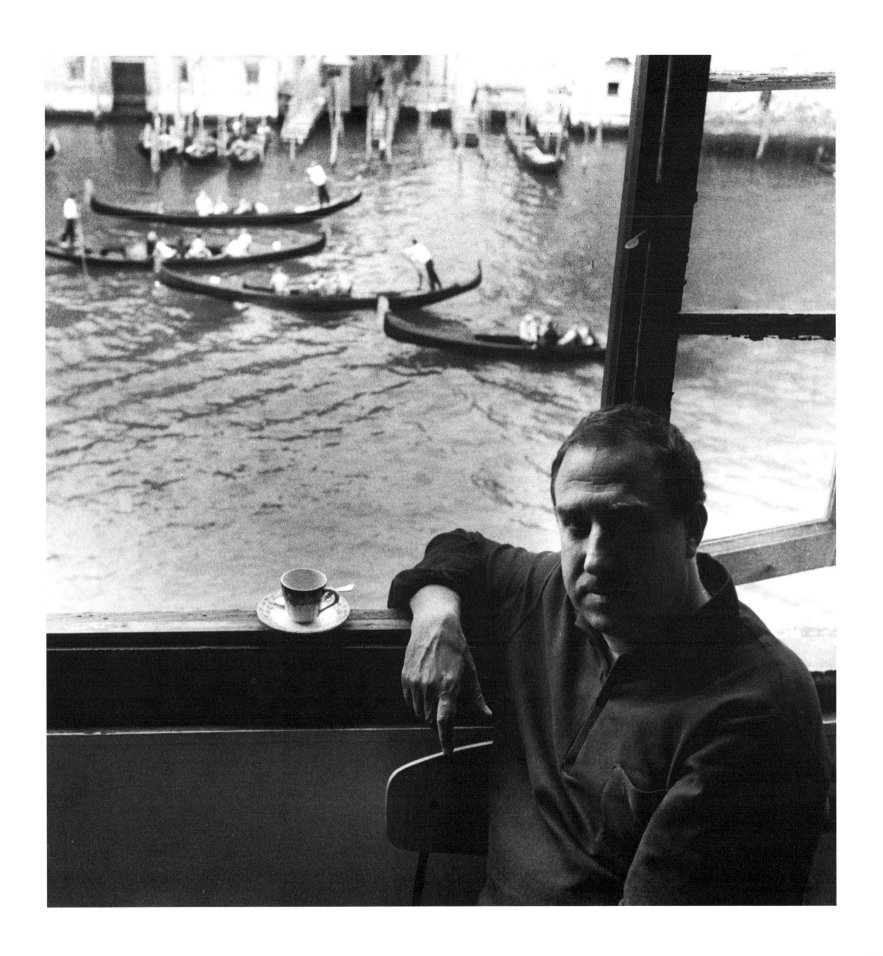

ITALY
'50s

Carlo Levi, a writer, a painter, and a physician, who spent the war years exiled in Eboli. His novel *Christ Stopped at Eboli* is based on his experiences in that village. *At left* are a shelf and wall in his studio.

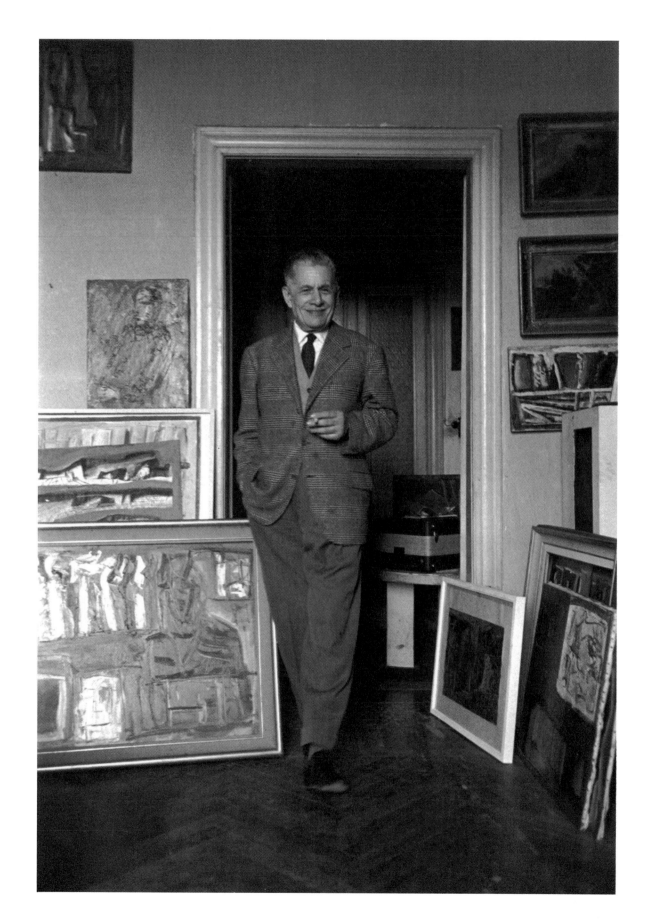

Mario Sironi, one of the artists who declared their break with traditionalism in the Manifesto of Futurist Painting in 1910.

Marino Marini is internationally renowned for his beautiful series of bronze sculptures of horses and riders, jugglers, and dancers.

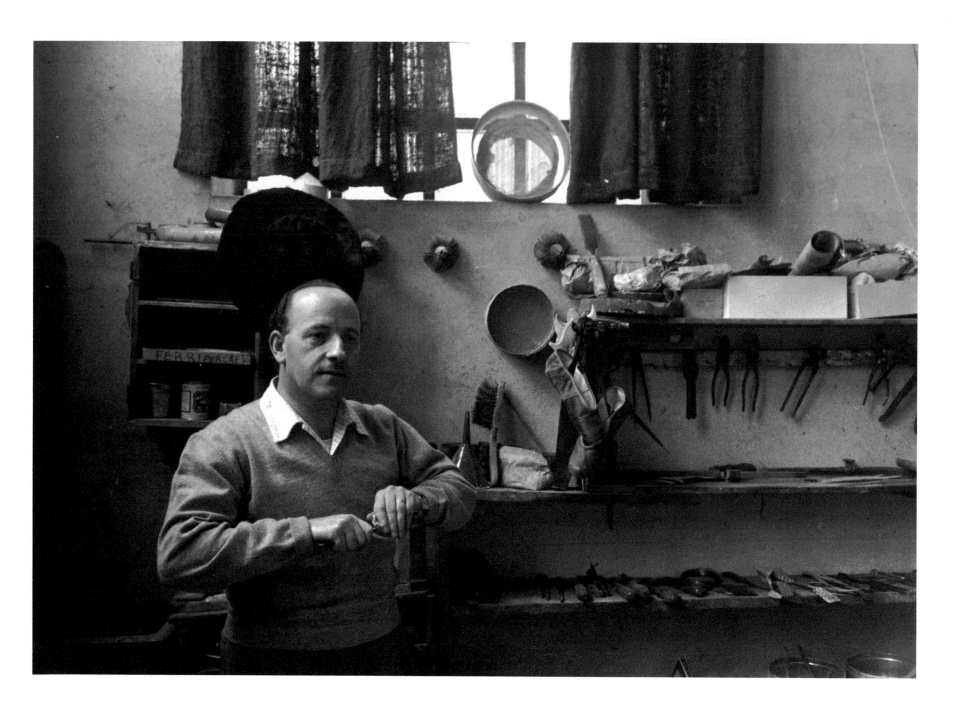

ITALY
'50s

Milanese sculptor Giacomo Manzù blended classical and modern styles into harmonious forms. In 1949 he won the competition to carve the *Porta della Morte* (Door of Death) at St. Peter's in the Vatican.

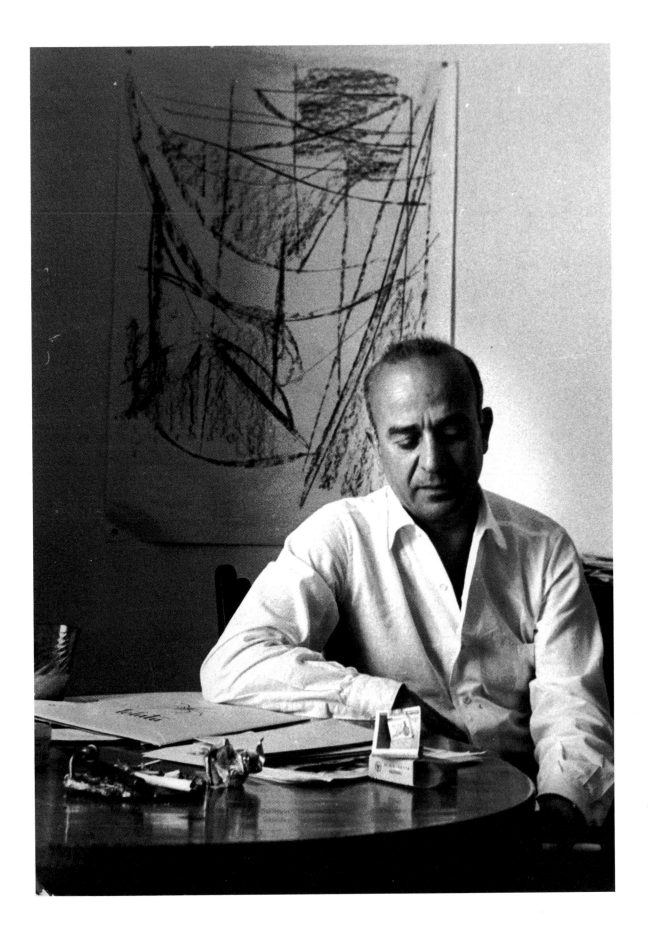

Antonio Corpora, the well-known Roman painter, presented us with a marvelous collage as an homage to our cat, Louis. Constructed of corrugated board, paper, paint, and endless yards of twine, it was entitled *Cat with a String*.

Artist Fausto Pirandello and
his wife in their apartment
in Rome.

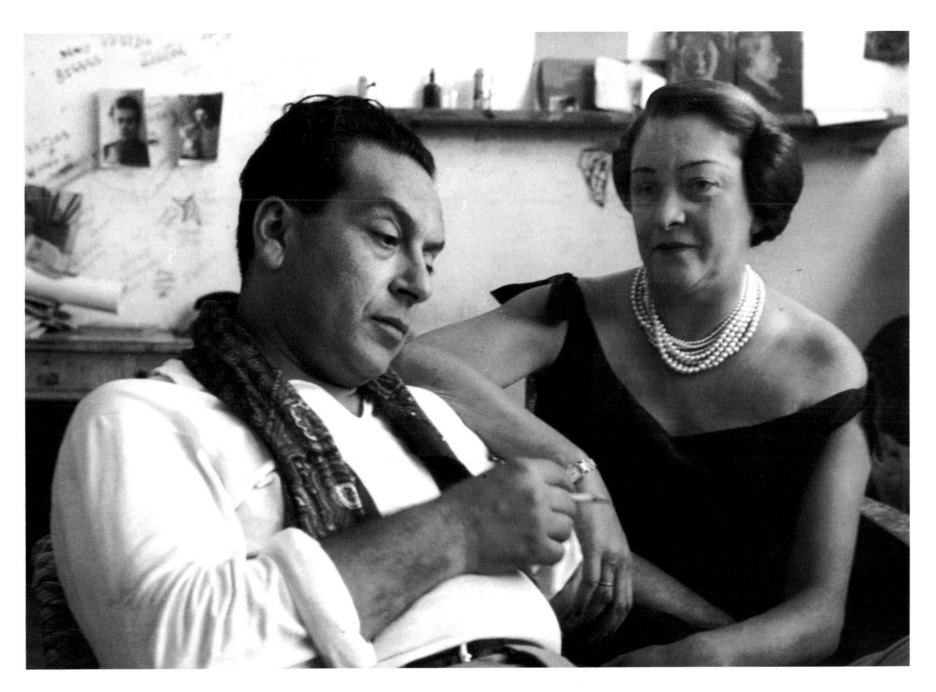

Renato Guttuso and his wife, Mimise. Guttuso turned
to abstraction in revolt against the neoclassicism of the
Fascists, but later returned to more figurative work to
express his social ideas.

Giulio Turcato, known for his
paintings of abstract forms, is
ignored by a Roman cat.

Alberto Burri, an internationally famous Italian painter, gathered materials from scrap heaps to make collages. His hobby was marksmanship, and his target in this case was a beer can. Shot full of holes, it became an abstract sculpture, which Burri gave to me when I called it a new art form.

Giuseppi Capogrossi switched abruptly from figurative to completely abstract painting. His trademark is the use of a trident or claw form in abstract designs.

Carla Accardi, one of the few women painters in Italy, is a modernist working in tempera, varnish, and plastics.

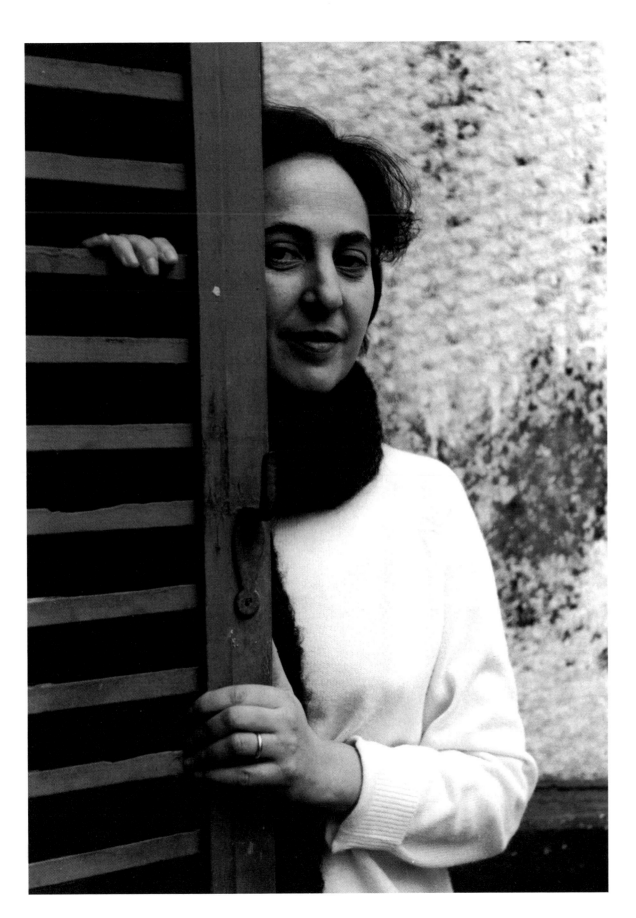

Left: Sculptor Alberto Viani seems to be part of a spatter painting himself here. His sculptures of human forms, blending figurative and abstract approaches, were condemned by the Fascist regime.

Right: Painter and graphic artist Bruno Caruso lunching *al fresco* at the restaurant Dal Bolognese in the Piazza del Popolo.

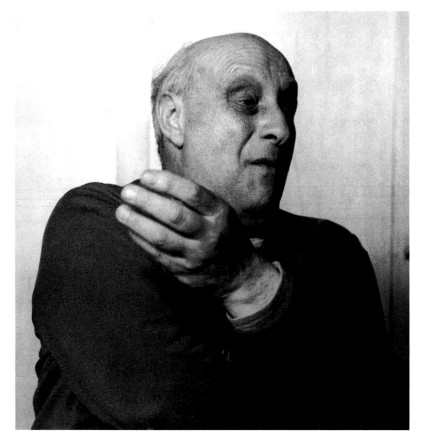

Roberto Melli, the Roman painter, uses typical Italian hand gestures to make a point. We were talking about Picasso, and Melli's hand is saying, "This was a painter!"

"Believe me, I know a good painter from a bad one."

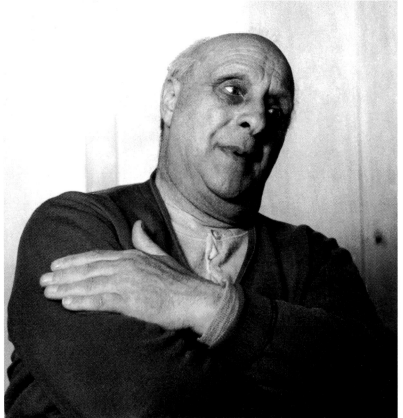

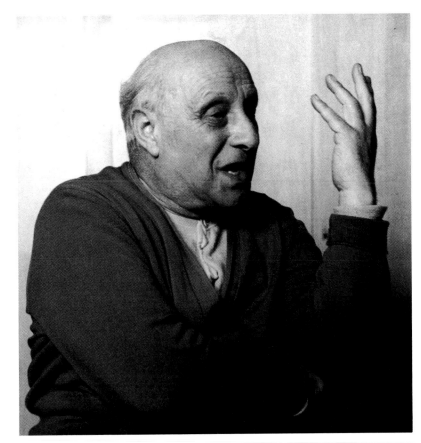

Melli holds up four fingers, each representing a painter he respects: van Gogh, Matisse, Miró, and Gauguin.

As Melli describes the intricacies of Picasso's *Guernica,* his face shows admiration, and his gesture emphasizes the importance of the work.

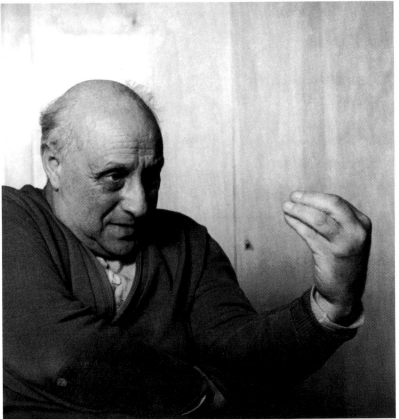

Painter Mario Mafai rebelled against Fascist directives by complying with the instruction to paint flowers but composing his still lifes of dead roses.

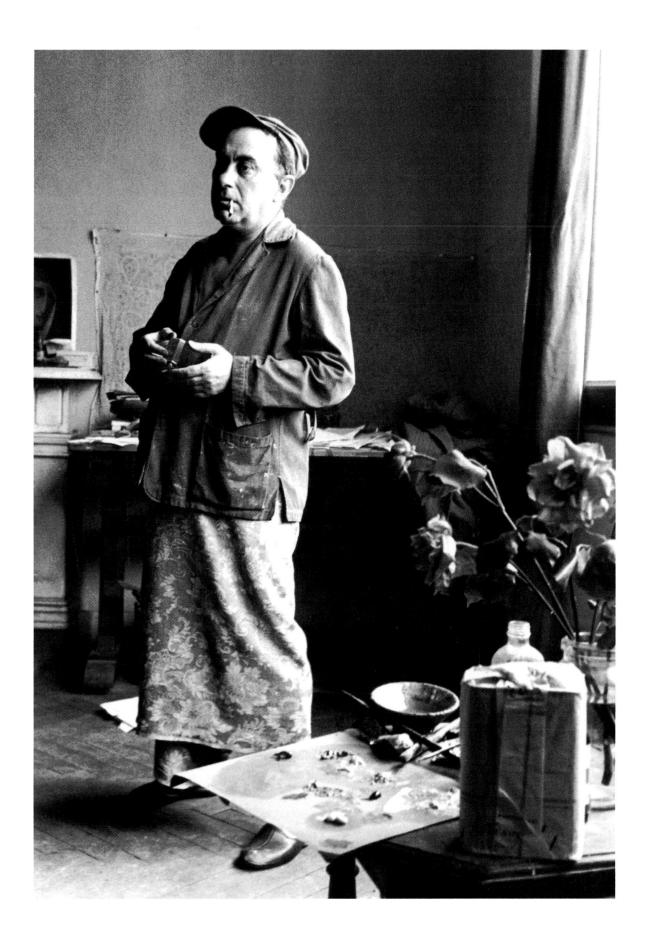

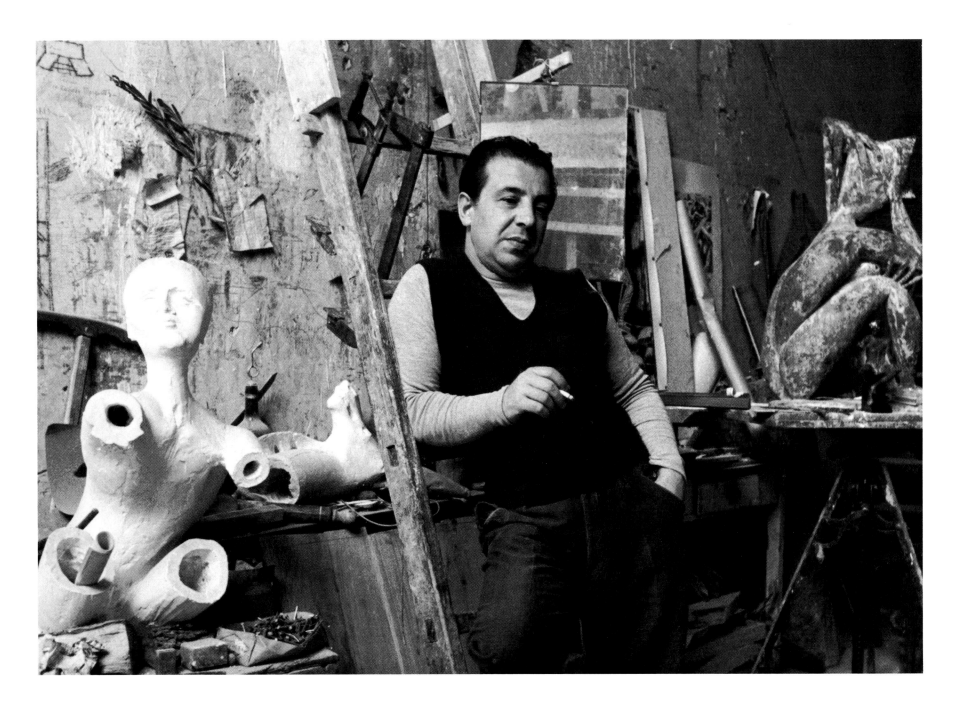

ITALY
'50s

Pericle Fazzini, a sculptor with a fiery spirit, produced imaginative yet realistic works noted for the inventiveness of their distribution of volumes.

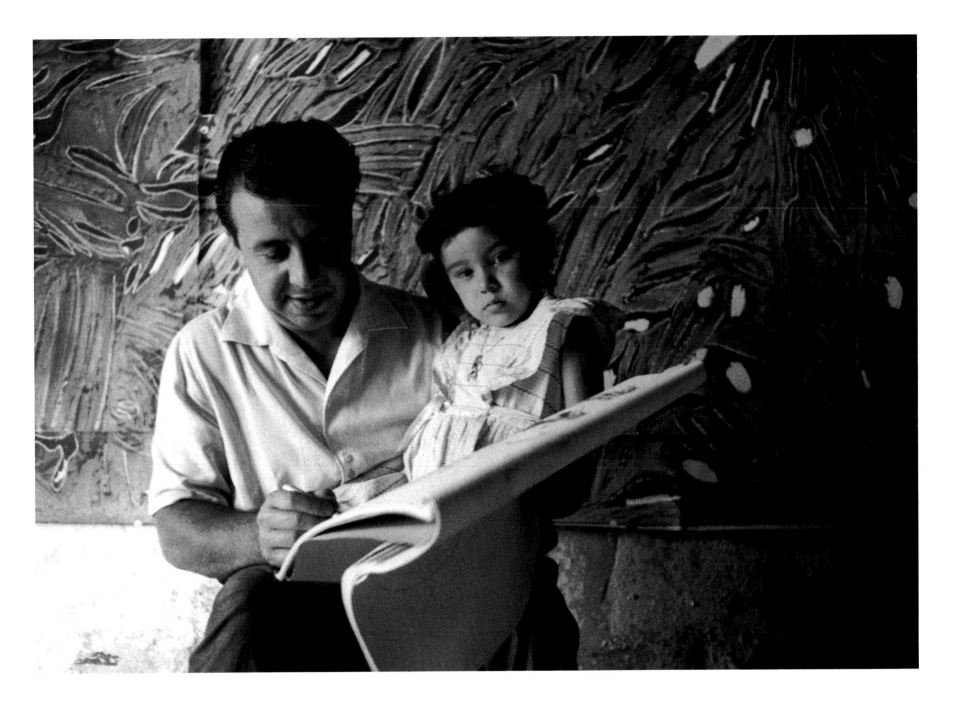

ITALY
'50s

Fazzini with his daughter.

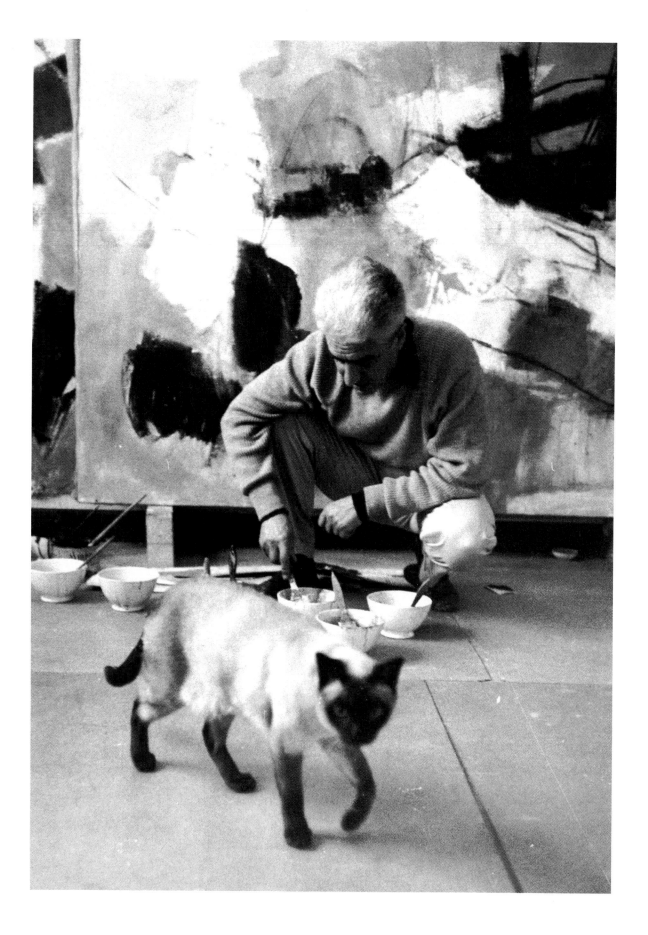

Afro liked to mix his paints on the floor while working on a mural-sized painting. He welcomed our cat, Louis, who sometimes left paw prints in Afro colors on the studio floor. Afro mixed his colors on palettes that consisted of newspapers spread on a board. The combination of pigments formed an abstract pattern of startling beauty, and we asked him to give us one of his palettes. He did so, amused by our request, and signed it "To Sandy Roth, who must be crazy to want this!"

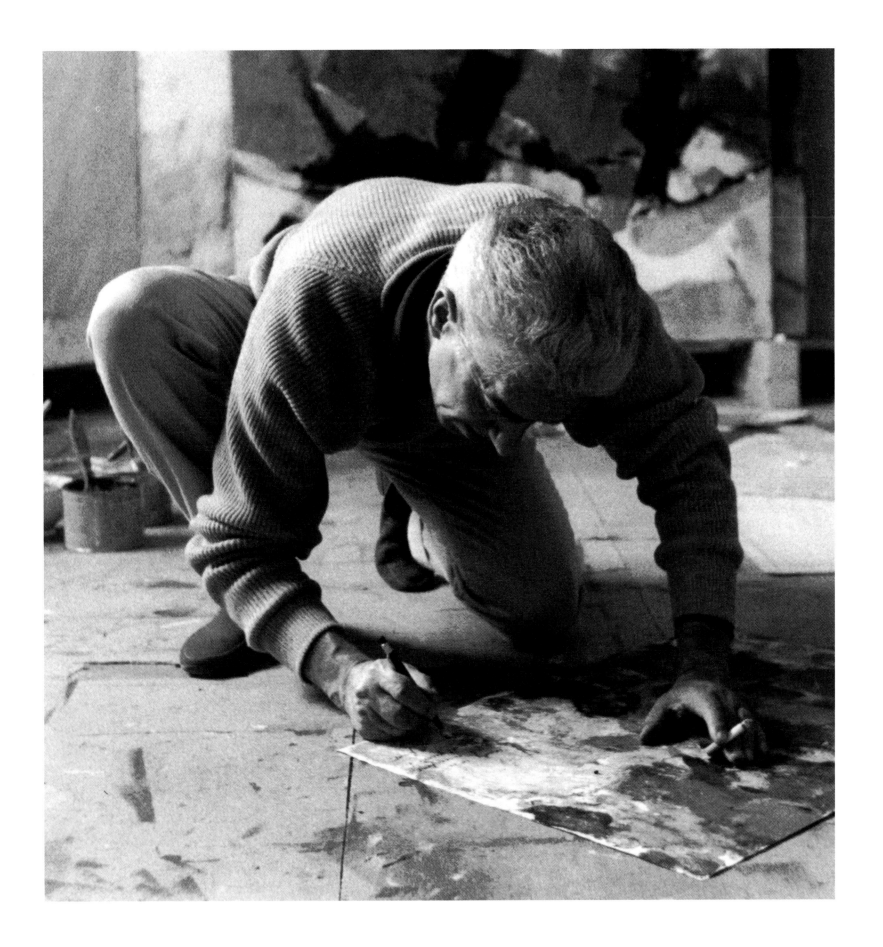

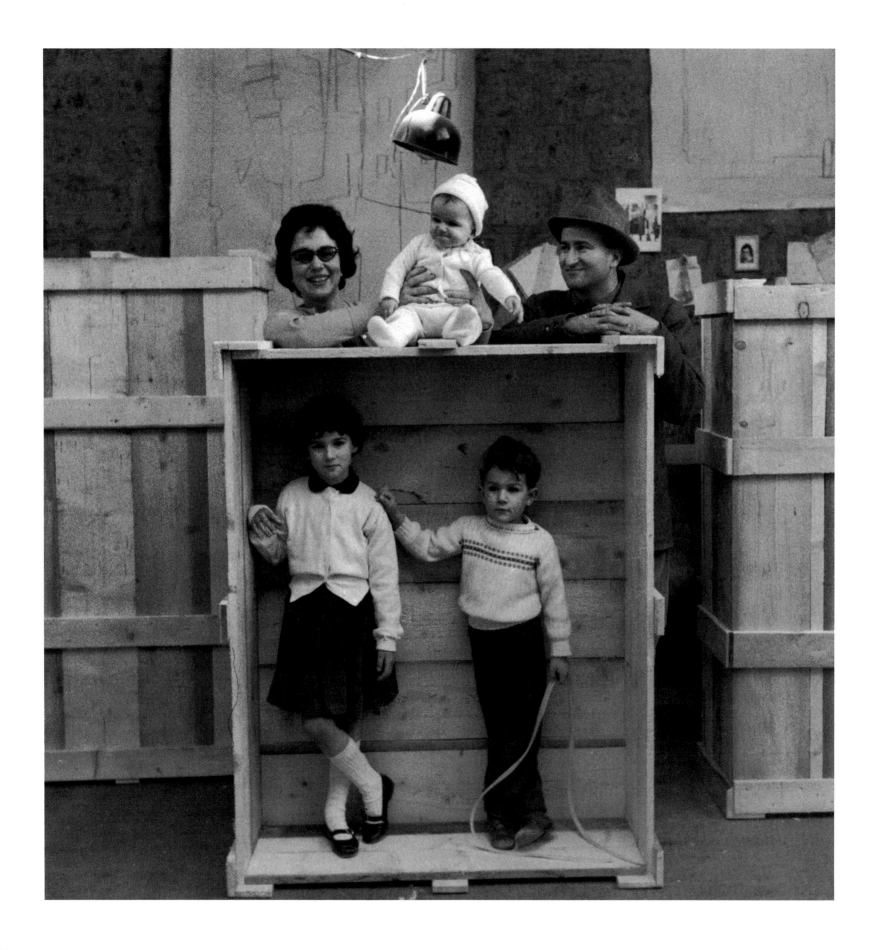

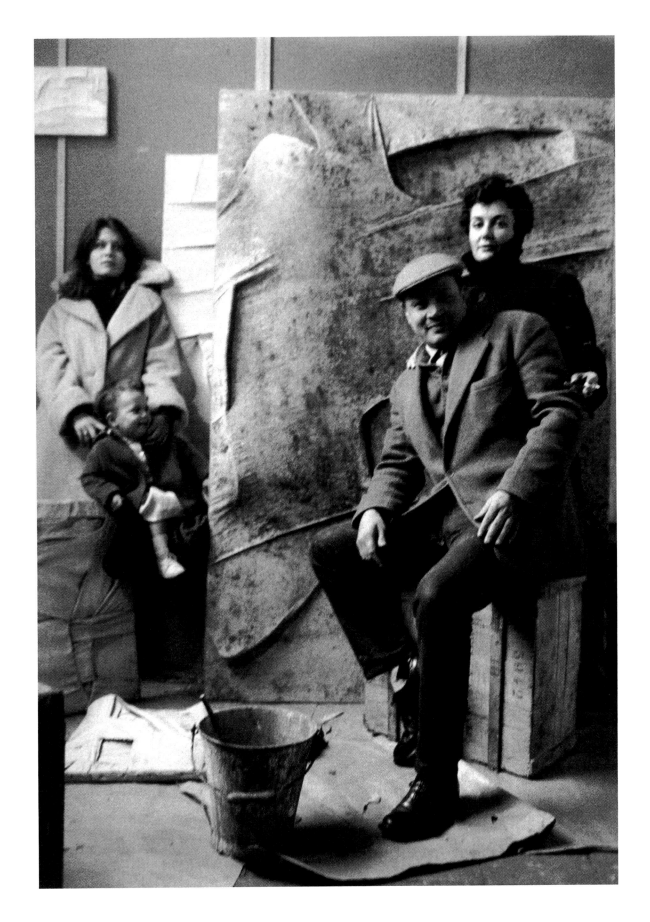

Left: Sculptor Pietro Consagra and his family. Consagra was a founder of the Forma group in 1947, the earliest Italian post-war nonfigurative movement.

Right: American artist Salvatore Scarpitta and his family in Rome.

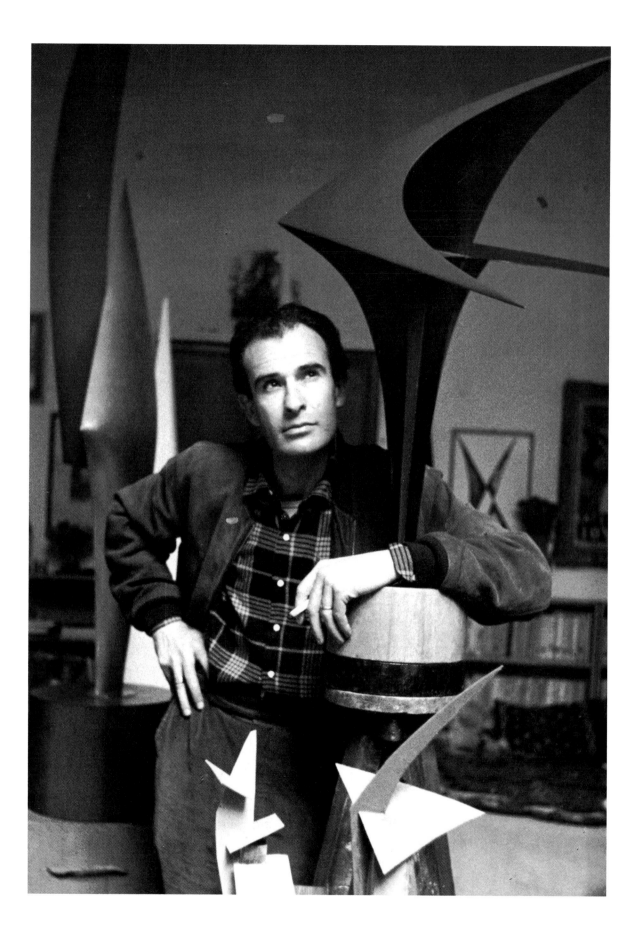

Sculptor Nino Franchina with
some of the graceful curves of
his work.

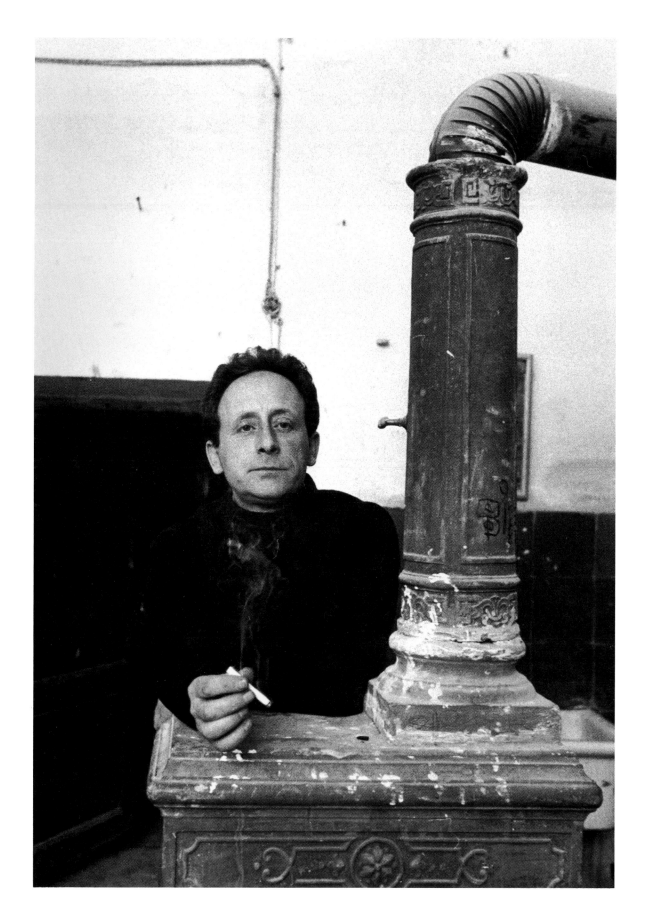

A portrait of ceramic sculptor
Leonardi Leoncillo in an
unexpectedly symmetrical
framing of pipes.

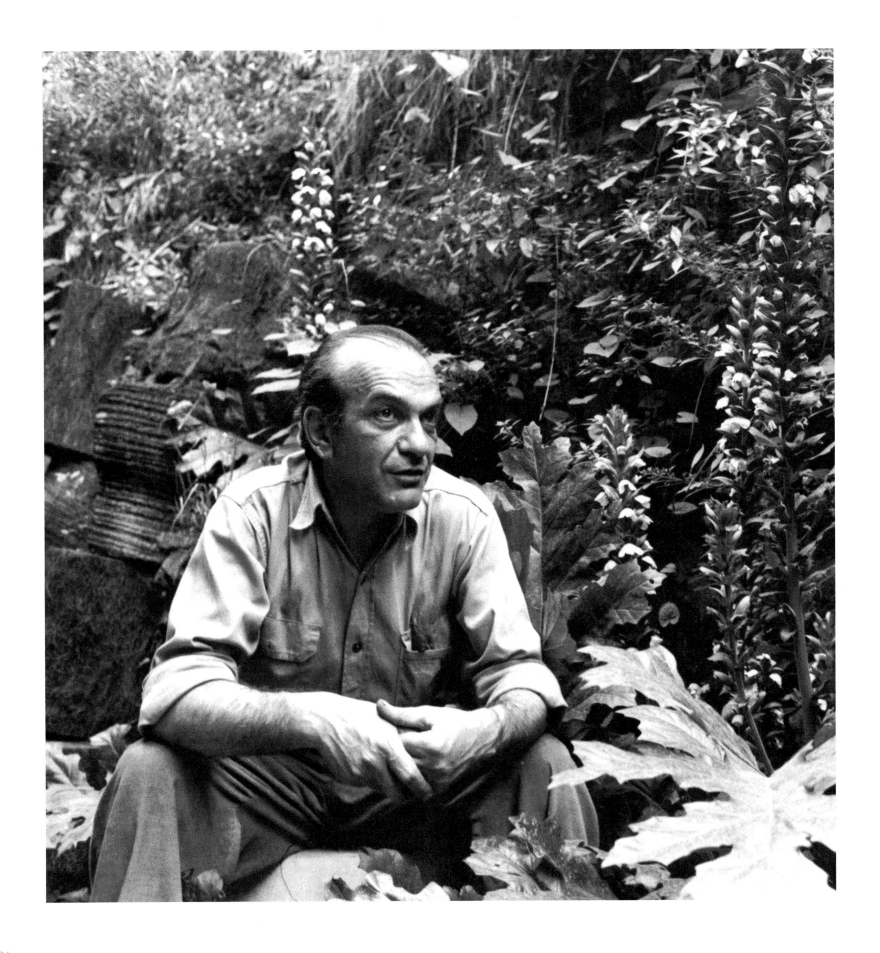

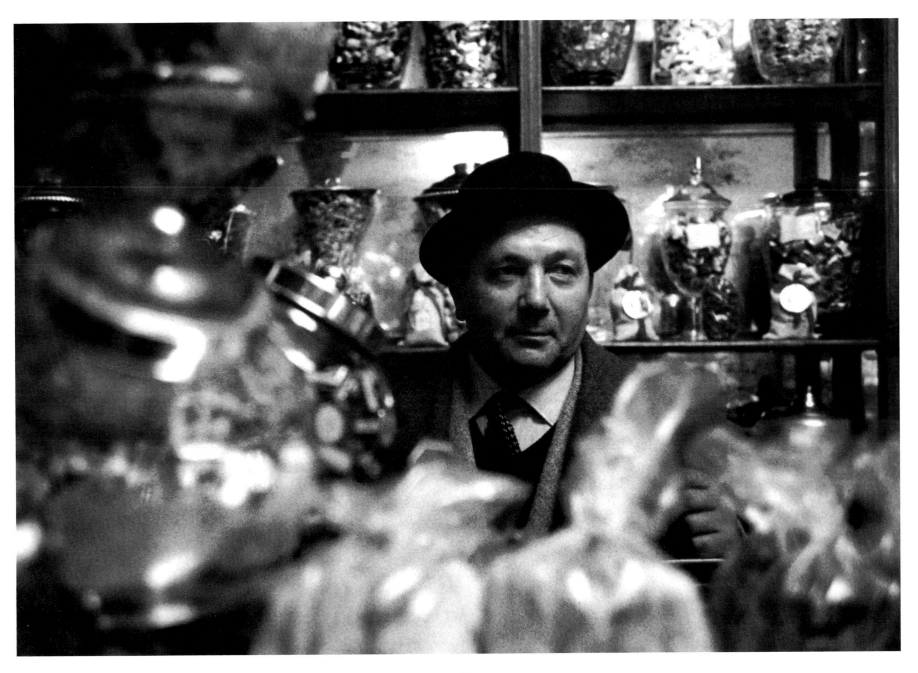

Above: Toti Scialoja, one of the Roman artists who worked with Vinavil in his paintings and collages.

Left: Roman painter Corrado Cagli in his garden.

ITALY
'50s

Rosati's, a café in Piazza del
Popolo, is the prescribed meet-
ing place for the artists and
writers in Rome. At times,
curious tourists will infiltrate
this sanctum sanctorum and
strain their eyes looking for
celebrities. They might sit next
to Alberto Moravia without
recognizing this important
literary figure. Here, meeting
for a pre-lunch Campari, are
Pietro Consagra, Nino Fran-
china, Afro, and Toti Scialoja,
all famous contemporary
Roman artists.

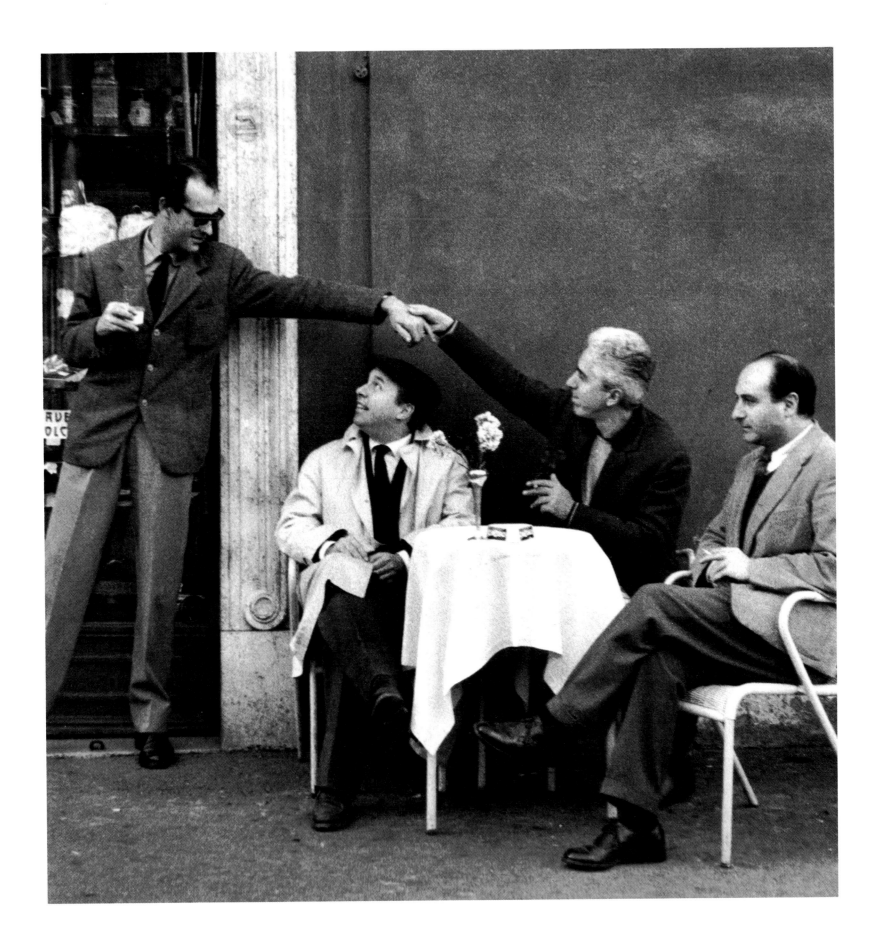

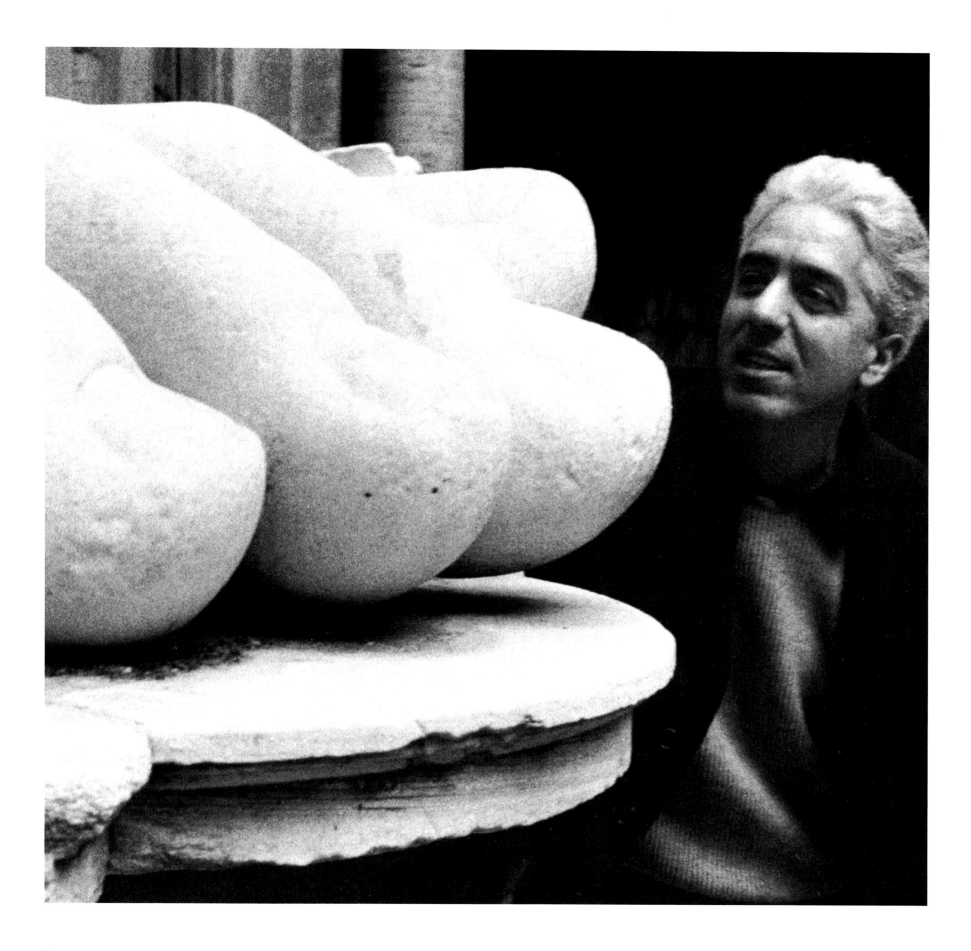

This book was designed by Sharon Smith, San Francisco. The text type is Bernhard Modern; the display type is Antique Open. The type was set by Ann Flanagan Typography, Berkeley, California. Page mechanicals were prepared by Joan Olson, San Francisco. Production was coordinated by Zipporah Collins, Berkeley. The text paper is 80-pound Patina Matte number 3 free sheet. The cover stock is 15-point Carolina. The endpapers are printed on 80-pound Multicolor Antique Gold. The photographs are 150-line screen duotones, prepared by Ringier America, Olathe, Kansas. Printing and binding were done by Ringier America.